NO EXPERIENCE REQUIRED!
WaTeR-SOLuBLe OiLs

NO EXPERIENCE REQUIRED!

WaTeR-SOLUBLe OiLs

Mary Deutschman

NORTH LIGHT BOOKS
CINCINNATI, OHIO
www.artistsnetwork.com

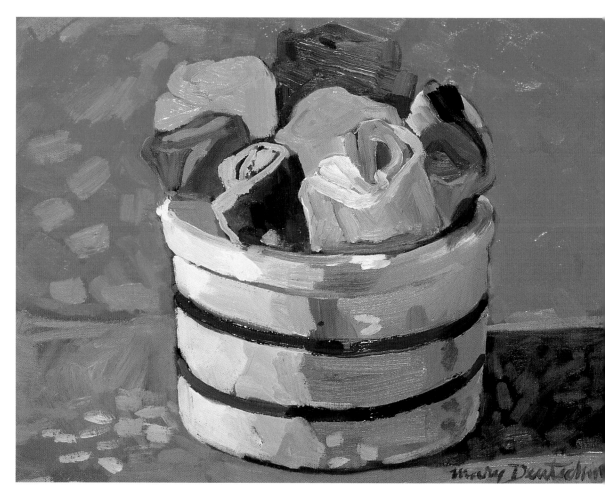

POT WITH TOWELS
9" × 12" (23cm × 30cm)

Other fine North Light Books are available from your local bookstore, art supply store or direct from the publisher.

09 08 07 06 05 5 4 3 2 1

Library of Congress Cataloging in Publication Data
Deutschman, Mary.
 No experience required: water-soluble oils / Mary Deutschman.
 p. cm
 Includes index.
 ISBN 1-58180-608-6 (alk. paper)
 1. Painting—Technique. 2. Water-soluble oil paint. I. Title: Water-soluble oils. II.
Title.

ND1473.D475 2005
751.45—dc22 2004028390

Edited by Christina Xenos
Art direction by Wendy Dunning
Interior design and production by Barb Matulionis
Production coordinated by Mark Griffin

F·W PUBLICATIONS, INC.

METRIC CONVERSION CHART

To convert	to	multiply by
Inches	Centimeters	2.54
Centimeters	Inches	0.4
Feet	Centimeters	30.5
Centimeters	Feet	0.03
Yards	Meters	0.9
Meters	Yards	1.1
Sq. Inches	Sq. Centimeters	6.45
Sq. Centimeters	Sq. Inches	0.16
Sq. Feet	Sq. Meters	0.09
Sq. Meters	Sq. Feet	10.8
Sq. Yards	Sq. Meters	0.8
Sq. Meters	Sq. Yards	1.2
Pounds	Kilograms	0.45
Kilograms	Pounds	2.2
Ounces	Grams	28.4
Grams	Ounces	0.04

About the Author

Mary Deutschman was born Mary Elizabeth Lloyd in Cleveland, Ohio. Even though her parents encouraged her to have a more practical career, she pursued art as her life's work. She became a fashion illustrator and designer and balanced those with motherhood. Later, as an art director, she learned about related fields like photography, printing and merchandising and eventually ran her own business.

It was then that she met Dan, her second husband, and moved to Boston to be with him. They took a trip to Paris—the beginning of her painting inspiration. When they returned, she studied painting in Boston and later in Pittsburgh. The couple moved back to Cleveland where Mary began showing her work.

Mary teaches painting for the Cleveland Institute of Art, has shows, and paints whenever possible. Many paintings can be seen on her website <http://www.marydeutschman.com>.

Acknowledgments

I could not have done this book alone. For the people who helped, I am extremely grateful. Rob Wetzler, who did a superb job on the photography. Kevin and Agnes Hogan who did so many things I did not have time to do. My husband, Dan, for taking me out to dinner every night. Tim Hopper at Holbein, Marsha Babbler at Grumbacher, David Pyle at Windsor Newton and Loretta Sias at Picture Perfect Products for my technical information. The people who produce the books that allow teachers to teach to a bigger audience. Thank you, North Light Books, for giving me a chance. To Christina Xenos, my editor, who was always there with her help and encouragement. To Bill Jean, who gave me the opportunity to teach many years ago. To my students, who encouraged me to write things down. Finally, I am grateful for all the museums that display our best teachers of painting. Please support them with your membership.

Dedication

To my husband and best friend, Dan.

Table of Contents

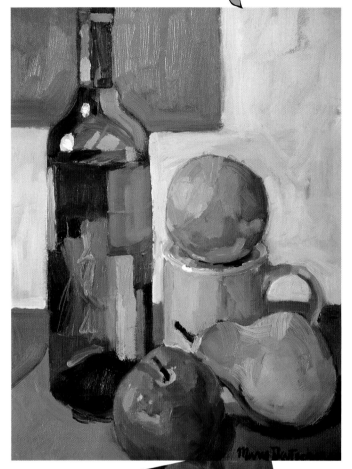

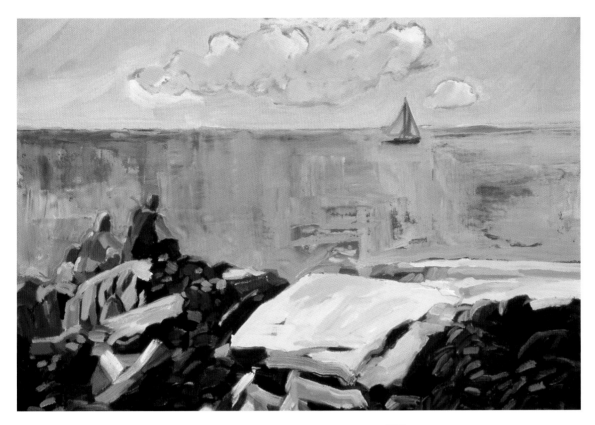

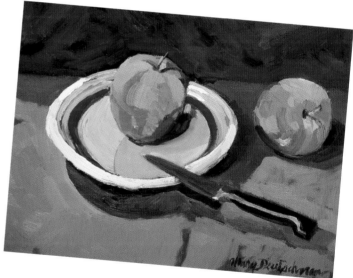

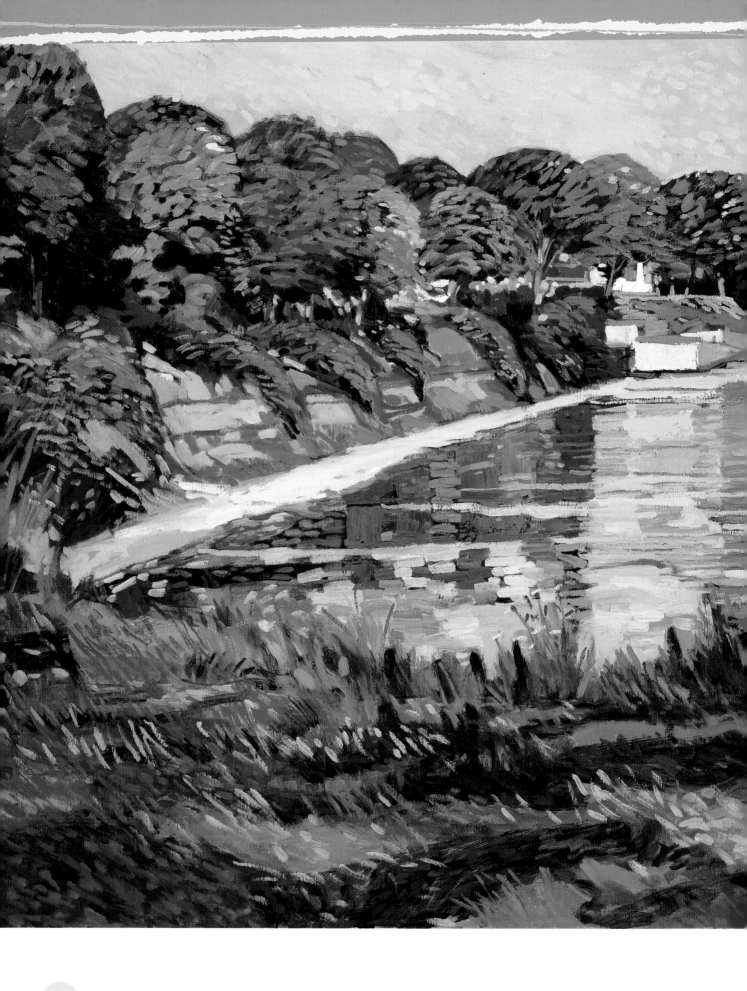

When I was asked to write this book, I was thrilled. When writing it became a reality, I thought, "What am I thinking? I can't do this." I paced the floor, thinking about how unprepared I felt. What if it isn't good enough? Then I remembered words my father said, "When you are afraid to do something, just take the first step."

Many people would like to paint but feel the same way. They think they are not capable of doing a painting. They think they are not good enough. They would really like to paint, but they don't have the time, the room, or their refrigerator needs to be cleaned. They often say they can't draw a straight line with a ruler. They have no idea where to start. You don't start with a straight line and a ruler, you start with your willingness to try something new. Take the first step.

This is your chance to learn from the beginning. If you want to make it really easy, buy some house paint and a big brush and paint on newspaper. You will learn how it feels to paint. The rest of your supplies you can buy later. How easy is that?

The next thing to do is start looking through this book. I know it will help you. Do something for yourself, for a change. You know, make it a nice day.

BAY PARK BEACH CLIFF
48" × 60" (122cm × 152cm)

Getting Started

Now that I have told you to take the first step, I will show you how to do it, but you are going to have to make the time. Make it one hour or six. It can be when the kids are in school, or while you're sitting in the car with your sketchpad waiting for the dance class to be over. Try working after dinner when the dishes are done. It's like exercise—do it for yourself.

Take the time to designate a place to paint. Sure, you can paint outdoors, but probably not at night or in bad weather. You, at least, need a place to keep all of your materials. A room with a door you can close to keep little ones out and you in is best. Take a look inside this chapter at my studio. Borrow a few ideas to set up yours.

Make your shopping list after reading about the supplies that you will need. Buy a few paints, a few brushes, a palette knife and a canvas paper pad at least. Make it what you can afford. Don't worry about what to buy. Everything is listed here (page 19).

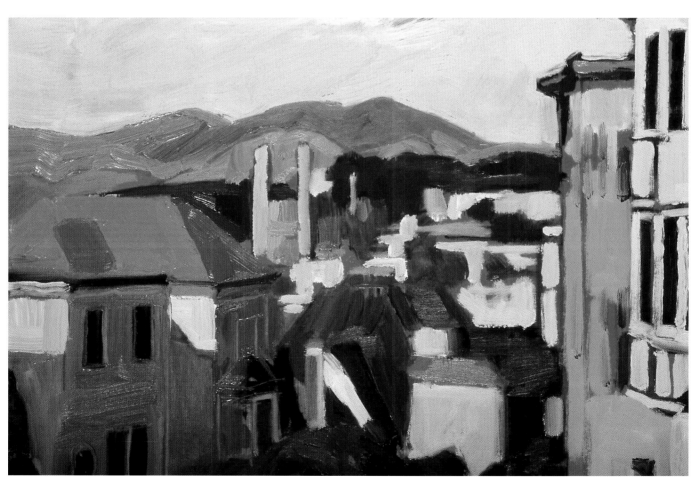

SAN FRANCISCO CASTRO
12" × 16" (30cm × 41cm)

Water-Soluble Oils: What Are They?

Traditional oil paints have been used for many years, but not without problems. They are cleaned up and thinned with toxic solvents. These toxins may produce allergic reactions. For many, the odor also is offensive. To all they are volatile and hazardous, and artists who have problems with solvents are not always happy with acrylics or watercolor as a substitute for traditional oil paints.

Water-soluble oils (sometimes called water-mixable oils) are very much like traditional oils but they are used with water instead of thinner to dilute and clean up. The color in the tube contains no water, only water mixable linseed oil. Water may be added to thin, but in small amounts. The benefit of using water-soluble oils is enormous for those who are troubled by the use of thinner. They cause fewer breathing and skin problems.

These paints are a wonderful alternative to traditional oils. They have the same buttery feeling, the same intensity and the same volume. If you have never tried water-soluble oils, I suggest trying a few tubes or a starter set. If you are a water media painter, water-soluble oils can expand your painting experience.

Materials to Use With Traditional Oils
Traditional oils can be used with the medium Liquin. They are thinned and cleaned up with Turpenoid or turpentine or thinner.

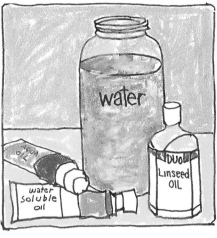

Materials to Use With Water-Soluble Oils
Water-soluble oils can be used with the medium linseed oil (specially prepared for these paints); is both thinned and cleaned up with water. They are better for travel (no solvents).

WORDS TO KNOW

SOLVENT A substance, usually liquid, used to dissolve, thin or remove another substance such as paint.

THINNER A fluid (turpentine or mineral spirits for traditional oils, water for water-soluble oils) used to decrease the viscosity of another.

QUICK TIP

TAKE CARE OF TUBE COLORS

You will be surprised how many times hardened paint can rob you of painting time. Follow these instructions to keep your paint fresh:
- Always replace the cap on the tube.
- Open the tube with pliers if needed.
- Squeeze from the bottom just like toothpaste.
- Clean off the opening with a tissue before putting on the cap.

Traditional Oil

Water-Soluble Oil

Appearance of Traditional Oils vs. Water-Soluble Oils
They both look the same and behave the same on canvas and canvas paper. Water-soluble oil may dry faster.

Easel and Palette Materials

Easel

Easels can be anything from a chair turned upside down to a heavy-duty H-frame variety with a winch to allow you to raise and lower heavy canvases while you work. I do advise buying the most sturdy easel you can afford, as you will find yourself always wanting and needing a bigger one.

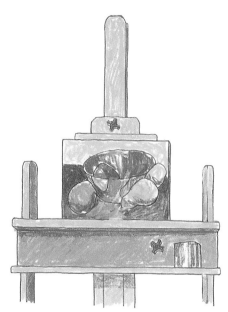

Easel

USE A PALETTE KNIFE FOR MIXING

Always mix color with a palette knife. It is so much easier than continually cleaning your brush.

If you prefer to sit, there are many tabletop designs that work. A drawing board with a slant can serve your purpose. If you paint outside, you will want a French easel. It has collapsible legs to make it easier to transport and an attached paint box and palette.

Palettes

A piece of glass covering a table is a good solution for a studio; a paper palette is easy to clean up. I use both. The glass must be cleaned regularly or paint will become very hard and difficult to remove. Clean with a single-sided razor, water and a paper towel. I must admit that paper palettes, when taped to your taboret (page 21), are very easy to use. You can easily change them once or twice a day.

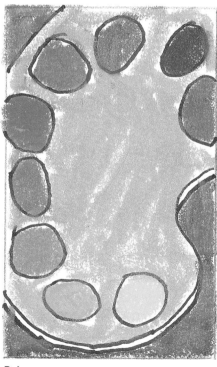

Palette

Palette Knife

Use it to mix paint and scrape down unwanted areas. While the paint is wet on your canvas, you can use the tip to draw in the paint or correct the basic drawing. Use the side for scraping off unwanted paint. The knife has a rounded end blade set into a hardwood handle. I prefer the trowel shape rather than straight, as it keeps my knuckles off the canvas and away from the wet paint. Don't buy your first palette knife from a catalog. You need to shop in an art supply store where you can test it. I prefer a knife that has a resistance. Many feel insubstantial.

Painting Knife

It is similar to a palette knife but has a sharper edge and a more triangular shape. You'll love doing an entire painting with just this knife and a palette full of juicy colors.

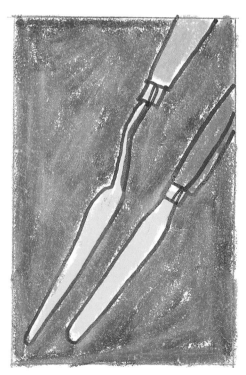

Painting Knife and Palette Knife

Brushes

The best way to learn what brushes are best for you is to go to an art supply store and compare the brushes. Look at high-quality brushes as well as the kind you might feel comfortable loaning to your preschooler. Handle the bristles and study the way they are shaped. You need to consider texture, size, price, and shape. Ask a salesperson to recommend brushes for use with water-soluble oils.

I find bristle brushes well suited to my needs. I like the substantial way they feel and the strokes they make. The brushes that work best with water-soluble oils are synthetic brushes developed specifically for water-soluble oils. They also hold up well when soaked in water.

To start, buy three sizes each of brights (square, stiff), flats (rectangular, flexible), filberts (rounded edges) and rounds (pointed tip, detail). Try nos. 2, 6 and 10 or another combination of small, medium and large. Buy a 1-inch (25mm) and 2-inch (51 mm) craft brush at a hardware store (for painting large areas). Fan brushes are good for blending but not necessary.

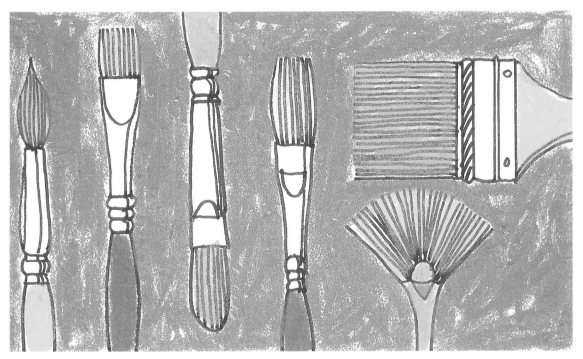

Brushes

QUICK TIP

AVOID BRUSHES THAT SHED
Use your old and beat-up brushes for scrubbing paint. Buy brushes that have a resistance when pressed against canvas, ones that return to their original orientation and retain their working edge. Limp brushes need not apply.

Using Your Brushes

Brushes come in a variety of shapes and sizes. Learn how each shape works best for you. The shape of the brush head describes how the stroke behaves. Experiment with a variety of brushes on newspaper, brown bags or scraps of paper. There are no rules in art. Don't be afraid of making a mistake. Remember how free you felt as a child with a big brush?

MATERIALS

SURFACE
Scrap paper

BRUSHES
Nos. 4 and 8 rounds • Nos. 6 and 10 flats

WATER-SOLUBLE OILS
Assorted

OTHER
Jar of water (for rinsing brushes)

QUICK TiP

SHOW TEXTURE
If you want your brushstrokes to show the texture of the brush, use either no medium (such as linseed oil or water) or very little. Apply your paint on the canvas with very little pressure.

Loading a Brush
Dip a brush into the pile of paint. Pull the brush toward you when you pick up paint. Don't push it away from you; this damages the brush.

Working With a Flat Brush
Flats are good for straight edges. Hold your flat at a 25-degree angle and press lightly for visible brush marks.

Working With Large Flat Brushes
Use big, wide, flat brushes like a 1- or 2-inch (25mm or 51mm) for covering large areas. Using a small brush to paint a large area would be like cutting your lawn with a manicure scissors. Try as many different strokes as you can think of. Let the brush be an extension of your arm. Learn how the brush feels and what it can do. Hold it flat as if you were painting a wall. Change positions. Apply pressure, then lighten up. Hold the brush at the end of the handle, allowing it to move more freely. Make strokes using your entire arm, not just your hand. Turn up the music. Have fun.

Working With a Round Brush
Some rounds are good for detail because they have a pointed end. They are capable of making thick and thin strokes and curves.

Cleaning Your Brushes

Many people paint for years without knowing how to properly clean brushes. It's easy to get distracted and forget to clean them. Don't let this happen. Brushes are expensive. If they are stiff with dried paint, they should be thrown out. Never let the paint harden near the ferrule. Follow these steps for your daily cleaning method.

MATERIALS

BRUSHES
Dirty brush

OTHER
Jar of water • Mild soap •
Paper towel or facial tissue

1 Remove Excess Paint
Clean off excess paint with a paper towel to prevent unwanted paint from clogging your drain. Wear protective gloves.

2 Rinse the Brush
Rinse it in your jar of water and wipe with a paper towel or facial tissue.

3 Shampoo the Brush
Carry it to a utility tub (not the kitchen sink) and shampoo the brush with mild soap and warm water. Press the brush gently against the palm of your hand and work up a lather. Rinse and repeat until color is gone.

4 Reshape the Brush
Gently pull the brush into its natural shape. Lay it on its side until it dries.

QUICK TIP

BRUSH CLEANERS
If you would like to use something other than soap and water to clean your brushes, here are a few alternatives.

Masters Brush Cleaner cleans and conditions. It comes in a hockey-puck sized container.

Aquasol is a nonsolvent liquid.

Fels-Naptha soap is a heavy-duty laundry bar soap. I like it because it is bigger, more effective and less expensive.

Canvas: Buy It or Build It?

If Goldilocks were looking for a surface to paint, she would probably choose a canvas. It is taut and flexible enough to be just right. When I first painted, I didn't care if a canvas was coarse, loose, tight or falling apart. Now I want everything just right. Does it make my painting better? No. But it makes me happier. Eventually we all want both our porridge and all of our materials just right. Once you wade through and try the many options, you will find what you prefer.

Stretched

I like pre-stretched canvas for small works, 12" × 16" (30cm × 41cm) or smaller. I can buy a very smooth type ready-made that pleases me. For big paintings, I want linen on extra-heavy-duty stretcher bars. These canvases are not always easy to find and when you do, requirements may dictate that you buy three boxes, three per box. It is a big outlay of cash.

Unstretched

This comes in a roll of linen or cotton and and is sold by the yard. Linen is considered the best. It has a fine, even grain and stays taut. Cotton duck is the best alternative and is cheaper. You must buy stretchers (the wooden frame-like pieces that hold the canvas) and assemble the canvas yourself or hire someone to do it. If you buy canvas by the yard, take time to figure how many pictures you can make without wasting the fabric. Be sure to allow at least a 3-inch (8cm) overlap on each side for covering the sides and stapling to the backside. Canvas is sold either primed or unprimed. If you choose the ready-primed, you will have a choice of acrylic-based or oil-based primer. Water-soluble oils are best used with acrylic primer.

QUICK TIP

CANVAS ALTERNATIVES

Canvas paper This is a good alternative for canvas. It is sold in a pad form. It must be affixed to a stiff material (cardboard) to frame.

Canvas panels They are similar in texture to a stretched canvas, but do not have any give to them. You might find them harder to frame, as they are only ¼-inch (6mm) thick.

Masonite panels These are less expensive than canvas and good to transport. Sand the edges, coat the panel with gesso on the front, back and edges, sand it with fine paper, coat it with gesso and sand it again.

WORDS TO KNOW

TAUT Pulled tight: A taut canvas is resistant to the brush. There is no slack in it.

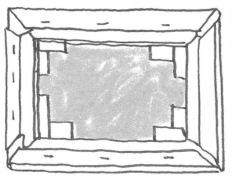

Canvas and a Canvas Pad

Stretcher bars come in many different lengths and thicknesses. For works larger than 24" × 24" (61cm × 61cm) use 2 ¼" × ¾" (6cm × 2cm) bars. For smaller than 24" × 24" (61cm × 61cm) use 1¾" × ⅝" (5cm × 2cm) bars. Wedges or keys fit into corner slots. Use these to make canvas more taut if it sags. You will need gesso to prime your canvas. Buy a staple gun (with a safety lock) and staples (slightly under ½" [12mm]). Don't forget those safety glasses. Canvas pliers will help you pull the canvas taut.

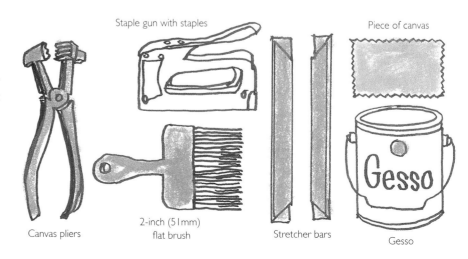

Staple gun with staples

Piece of canvas

Canvas pliers

2-inch (51mm) flat brush

Stretcher bars

Gesso

Preparing Your Canvas

If you opt for the unstretched canvas, follow these instructions to stretch it yourself. Before you start stretching your canvas, you have to join the four stretcher bars. Make sure they are squared up—this may take a few tries. Measure diagonals to make sure that they are equal. Secure each corner with a staple so it will survive the next steps.

MATERIALS

SURFACE
Canvas

BRUSHES
2-inch (51mm) flat

OTHER
Canvas Pliers • Gesso (to prime canvas, if needed) • Staple gun with staples • Stretcher bars (4 of them)

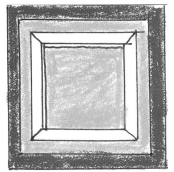

1 **Size the Canvas**
Lay a canvas roll on a table or floor, painting side down. Lay the stretcher bars on top of it, beveled edge facing down. Line them up with threads in the canvas. Cut the canvas 3 inches (76mm) beyond the bars.

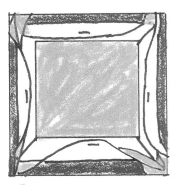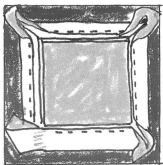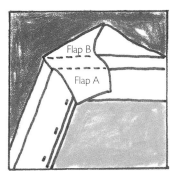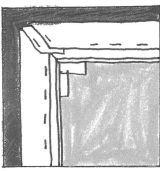

2 **Secure the Canvas**
Pull up the canvas to cover the sides of the frame. Secure it with one staple on the back-center of each bar. For example, imagine the frame is a clock: Put the first staple at 12:00, put the second staple directly below it at 6:00, until it is tight. Grip the canvas with your canvas pliers. Put the next staple at 9:00 then the final one at 3:00. Keeping the staples 2 inches (51mm) apart, start the next staple about 2 inches (51mm) to the right of the 12:00 staple. Work around the other three sides the same way. Staple on the left side of each center staple. Keep on going until only about 2 to 3 inches (51mm to 80mm) are left on the corners. This allows slack for the corner folds.

3 **Secure Flaps**
Hold the canvas around the corner with your left hand, creating Flap A. Hold in place. With right hand, fold over remaining fabric Flap B. Secure each flap with a staple. These corners should be as flat as possible.

4 **Prime the Canvas**
With a 2-inch (51mm) flat, paint the front and sides of the canvas with gesso. Cover the area by using a crosshatch method. When it is dry, give it another coat and let dry overnight before applying paint.

Additional Materials

Oil Pastels

Use oil pastels to plan the colors in your water-soluble oil paintings. Oil pastels are dust free and durable. They can be purchased in most art supply stores or in catalogs. They come in various quantities from a small, easy-to-carry set of fifteen colors to large sets for the studio that have 225 colors and come in a wooden box. Buy a small set or two that will allow you to test the size and smoothness before you invest in a large set.

Pens

I love Pentel felt-tip pens. I used them for years for my drawings in commercial art. When they are new, the tip is fine and has just the right amount of flow. There are many different kinds of pens. Pick one capable of a strong line and buy a few.

Pencils and Erasers

In my life there is one pencil: soft. I like a Design Ebony made by Sanford and Faber Castell 4B and 6B; all are lovely for sketching. Buy a kneaded eraser, but spend your time drawing not erasing.

Lamp

A clip-on desk lamp is an easy solution for lighting your still life paintings. I use a clip-on gooseneck style that holds one incandescent bulb.

Paper Towels/Facial Tissues

These work much better than rags, which expose your hands to paint constantly. Avoid those that are colored. White allows you to see where the color is. I do love Viva's very soft paper towels.

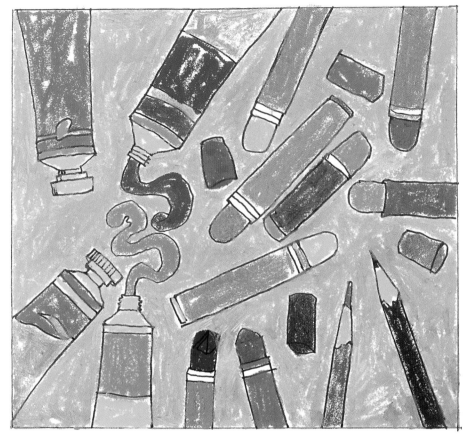

Pastels, Paint Tubes and Pencils

Pliers and Rubber Gloves

Both are very convenient for opening those tubes of paint. I always protect my hands by wearing latex gloves when cleaning up and washing brushes.

Large Jar of Water

Best if it doesn't look like your drinking glass—trust me.

Sketchbook

Don't leave home without it. Keep it small: 5" × 7" (13cm × 18cm).

Picture Perfect Viewfinder

This is a wonderful tool for framing and cropping a setup or landscape. It also filters out color so value can be more easily recognized, and you can see the divisions of your picture plain. This particular viewfinder also includes a value scale. Buy directly through website: <http://PicturePerfectViewfinder.com> or call 541-779-0723.

Index cards

Try 5" × 8" (13cm × 20cm) unlined. I use them for everything. Buy them in large packs of 500. You will find a million uses.

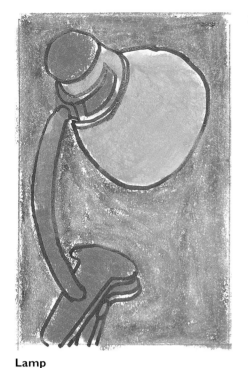

Lamp

Paper Towels

PROTECT YOUR HANDS
Scratching the surface of a bar of soap just before you paint will make cleaning your hands and fingernails easier. Painters with long, acrylic nails should wear gloves to paint if they can tolerate them for long periods of time.

SHOPPING LIST

To complete the exercises and demonstrations in this book,
you will need the following materials:

SURFACE
Stretched canvas or alternatives (page 16)

BRUSHES
Try nos. 2, 6 and 10 (or another combination of small, medium and large)
each of brights, flats, filberts and rounds; 1-inch (25mm) and
2-inch (51mm) flat craft brush (for painting large areas)

WATER-SOLUBLE OILS
Alizarin Crimson • Cadmium Orange • Cadmium Red Deep • Cadmium Red Light •
Cadmium Red Medium • Cadmium Yellow Light • Cadmium Yellow Medium •
Cerulean Blue • Dioxazine Violet • Lemon Yellow • Phthalo Green •
Raw Umber • Titanium White • Ultramarine Blue • Yellow Ochre
(Holbein paints have different names for the Cadmium colors.)

OTHER
Camera (to take reference photos) • Easel • Gesso • Index cards • Jar for water •
Lamp • Oil pastels • Painting knife • Palette • Palette knife • Paper towels or Facial
tissues • Pencils • Pens • Pliers • Rubber gloves • Scissors • Sketchbook • Viewfinder

OPTIONAL
These materials are only necessary if you are going to stretch your own canvas:
Canvas stretcher pliers • Staples • Staple gun • Stretcher bars

Arranging Your Studio

When I was house hunting in Boston, our focus was to find a place that had room for my studio. I had in mind a sizable, centrally located, light room. Our realtor, not understanding this, suggested that I use the laundry room for painting. Imagine it: six easels and art supplies in a laundry room?

QUICK TIP

GET VENTILATED
I had a fan installed in the wall of my studio to provide ventilation. Plenty of ventilation is a necessity when working with many art materials. The fumes from them can affect you, especially if you can't open a door or window. Continuous breathing of toxic art materials in a poorly ventilated room can hurt both your lungs and liver.

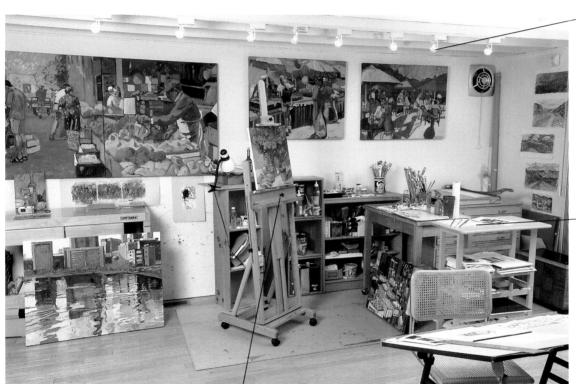

Lighting My lighting is on several tracks, and I prefer mini spots. I like plenty of bright light on my easel, my palette, and my paintings hanging on the wall. Vertical blinds on each window ensure complete darkness for taking photos of my paintings.

Taboret I use a microwave cart with wheels. I have covered the top in ¼" (6mm) glass which I had cut to size, and I use it as my palette.

My Studio
I love my studio. It has large windows facing north, the most constant of the light sources. In it, I have several easels that have seen me through my painting career, a taboret, an area for my music, a workbench for making frames and various shelves to hold my office supplies and my precious art books. My books provide me with endless inspiration. I buy them from museum bookstores when I travel.

Easels Two of my easels are large. Painting on large canvases requires moving them up and down. When you do it twenty times a day you want it to be easy. Because my easel has a back-mounted winch, I never have to handle the painting. Better for your back and hands.

WORDS TO KNOW

WINCH A pulley system with a crank for hoisting or lowering large canvases.

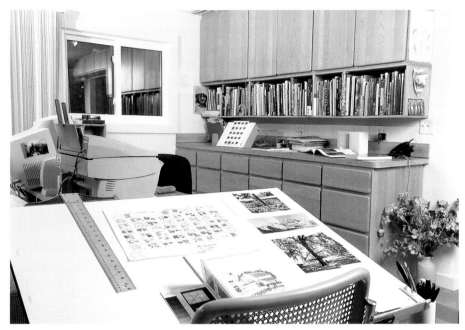

WORDS TO KNOW

TABORET A small portable cabinet. Most have a flat working surface on top and a set of drawers or shelves.

Computer Area

In addition to my painting area, my desk and computer area are essential for running a business. I use a computer to play with colors before I paint and also to store photos of my paintings. My database, done on Microsoft®Access®, contains my mailing list and painting table that stores information about each painting. The program also gives me the ability to put together price lists, write labels for slides, and print both mailing labels and display labels. My website<http://www.marydeutschman.com> has been a wonderful way for people to get to know my work.

Planning Your Workspace

I have had so many students tell me they really want to paint at home, but they don't know where to do it. Plan a room where you can set up a real studio. If you don't have the space, take part of a room and create some kind of separation. Clear off a table and set up a table easel. Make a space. Call it yours. It's much easier than having to drag everything out each time you want to paint.

PAINT UPRIGHT

Do not paint on a flat table. You need to see your painting in an upright, face-to-face position.

Color

Color is everywhere and lives in many forms of art. I like to compare color to music and a painting to a musical composition. Each is made of notes. The notes are given meaning when they are combined with other notes in a way that makes it enjoyable for us. Beauty lies in the arrangement.

See your subject as a composition of spots of color: spots of green, purple and orange for leaves, and spots of ocher, green and sienna for the ground. Learn to make your composition something that gives you joy. Translate what you have learned in life to your painting.

You can see color in many different ways: bright or subtle, light or dark, warm or cool. Observe the color in someone's skin, in reflections on a river, in the blush of a peach. Study the varieties of leaf color as you walk through the park. They are never just one shade of green. They are many shades of green, brown, yellow and orange. In the autumn, they become vibrant reds, vivid oranges and shimmering golds. File them in your memory. Remember the colors when you are mixing paint.

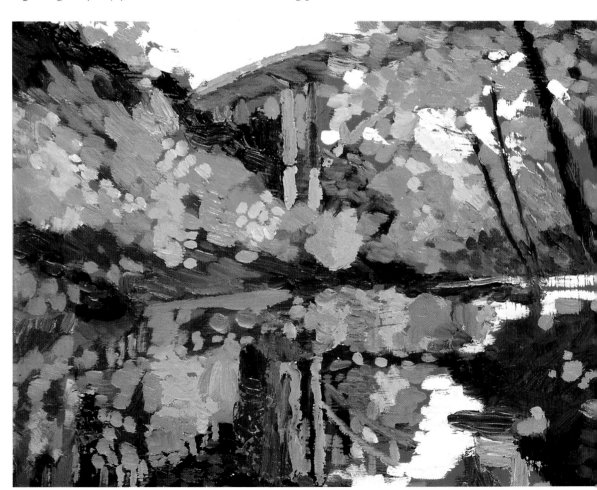

AUTUMN IN THE PARK
UNDER THE BRIDGE
9" × 12" (23cm × 30cm)

Color Basics

A color wheel is the best visual way to explain color relationships. This version addresses *primary, secondary* and *complementary* colors.

Primary colors The colors from which all others are made, with additions of white: red, yellow, blue.

Secondary colors Result from mixing the three pairs of primaries: green, purple, orange.

Complementary colors These are sometimes called *opposite colors.* They are the colors that are opposite on the wheel—where the arrows are pointing: red and green, purple and yellow, blue and orange.

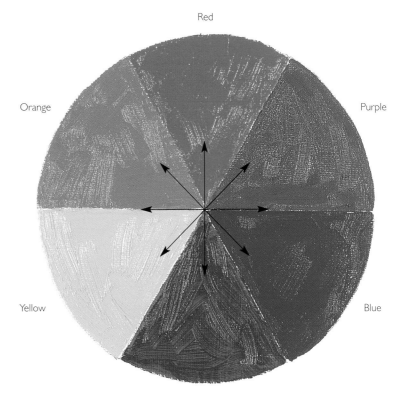

Color Wheel

MAKE YOUR COLORS INTENSE

Complementary colors intensify one another. They look the most intense when they match in tone and strength. Beauty can be created from color by sensitively positioning one color next to another. There are hundreds of options. Practice painting complements on index cards. Save the ones you like for your reference. Cut others up into strips and use them for bookmarks. Save a few for your friends.

Color Properties

Color changes constantly. When you paint a color, there are conditions like light and atmosphere that change how it appears. The sky could be a grayed blue. The leaves could be in shadow and look very dark. You should paint the color that you see, not the color you know something to be. For example, you know leaves as green, but direct sunlight makes them look a gray green or yellow green. Shade makes them look blue or purple and darker. To paint subjects realistically, you need to know how to recognize a value change or alter the paint. Understanding the properties of color will allow you to do this. The properties of color are *hue, chroma, value* and *temperature.*

Hue
This is the local color, or any color you can name. When we refer to a leaf on a tree as green or an apple as red we are referring to its hue.

Chroma
Intensity or brilliance of a color. You make a color less bright by adding white, black or its complement to it.

Value
This is the degree of lightness to darkness. White is the highest value, while black is the lowest. Practice making a color lighter or darker. You can make your painting believable by using the right value; the right color is not as important. It isn't always easy to see what value an object is. It may have texture, such as bark on a tree. Teach yourself to see the value, not the detail. A good way to do that is to squint or to take off your glasses to look at it. You will then see only the important tonal values.

Temperature
This is the tendency of color to be warm or cool. An object's color may look warm or cool depending on the light in which you see it. You represent what you see in nature by painting it in warm colors (yellow, red, orange) or cool colors (blue, green, violet).

Look at a white house or snow that is partly in bright sun and partly in the shade. The sunlit areas tend to look like they are tinged with yellow (a warm white). The shade looks more like a light blue or purple (a cool white).

Paints can be further broken down by the warm and cool tendencies in individual colors. Red may have a blue tendency (Alizarin Crimson) or a warm tendency (Cadmium Red). Yellow may be cool (Lemon Yellow) or warm (Cadmium Yellow). Blue may be cool (Cerulean Blue) or warm (Ultramarine Blue).

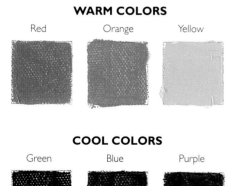

WARM COLORS

| Red | Orange | Yellow |

COOL COLORS

| Green | Blue | Purple |

Hue and Temperature

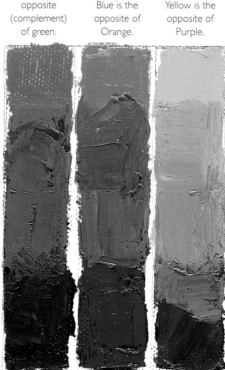

Red is the opposite (complement) of green.

Blue is the opposite of Orange.

Yellow is the opposite of Purple.

Chroma
Make a color less intense by mixing it with its complement. You can also make gray by mixing complementary colors. Squeeze out a little of each color in a pair of complementary colors. With your palette knife, bring half of each pile toward the middle. Blend. Add white to make gray. It may take a little adjustment to get the right balance.

Learn to Mix Values

Making a color lighter is easy—just add white. Adding yellow to red and orange will give you a more intense light value. Making a color darker takes practice. Follow the exercises on this page to match your colors to their values and learn how to make different values of each color.

MATERIALS

SURFACE
Canvas paper

WATER-SOLUBLE OILS
Alizarin Crimson • Black (Alizarin Crimson + Phthalo Green) • Cadmium Red Light • Cadmium Yellow Medium • Phthalo Green • Titanium White • Ultramarine Blue • Yellow Ochre

OTHER
4B or 6B pencil • Palette knife

Gray Scale

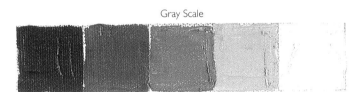

Compared to a Color

Adding Additional Colors to Make Darker Values
Make tube colors a darker value by adding a darker color. (A red can be darkened with Ultramarine Blue, Phthalo Green, or Alizarin Crimson). Compare each value to your gray scale.

QUICK TIP

THE PICTURE PERFECT THREE IN ONE
This viewfinder comes with a separate value scale. Punch a hole in the middle of each value. When you are trying to read a value of paint, move the card around until you find the best value match.

Dark Medium Light

Black

Phthalo Green

Cadmium Red Light

Ultramarine Blue

Yellow Ochre

Cadmium Yellow Medium

Create a Value Scale for Each of Your Colors
Do this exercise with each of your colors. Draw five 1-inch (25mm) blocks across the top. This will be your gray scale. Make the block on the left black, the one on the right a very light gray. Make the middle block a middle value gray. Make the remaining two values medium dark and medium light so you have a gradual scale. You will judge the other colors by these so be accurate. A viewfinder will help.

Squeeze a dab of five or six of your colors onto your palette. Place each of these under its corresponding gray value. Tube colors like Ultramarine Blue and Phthalo Green are very dark and will be under the black column, while your reds and oranges will probably be under the middle range column some yellows will be very light. Once you have placed the tube colors there, you will have fun filling in the rest of the values for each color.

The secret is in matching the values with the black scale. If you don't have black, make it from Alizarin Crimson and Phthalo Green. Then add Titanium White for the grays. Be sure to label each color after you make it and keep it for reference.

My Palette

These are the colors that I use most of the time. They will mix with just about any color imaginable. I do use Siennas and Umbers, but not as much. I never buy black. A more colorful black can be mixed from colors such as Alizarin Crimson and Phthalo Green. Most colors can be made from certain combinations of red, yellow and blue. Be selective about what you buy. Some combinations need certain paints to work. Cadmium Red Light and Ultramarine Blue will not make purple. Substitute Alizarin Crimson for Cadmium Red Light for the purple mix (page 28).

Manufacturers may call their paints by different names. Holbein does not use Cadmium in their water-soluble oils. What I have shown and named Cadmium Red Light could be called Vermillion. Holbein refers to Cadmium Yellows as Yellow Medium and Yellow Light.

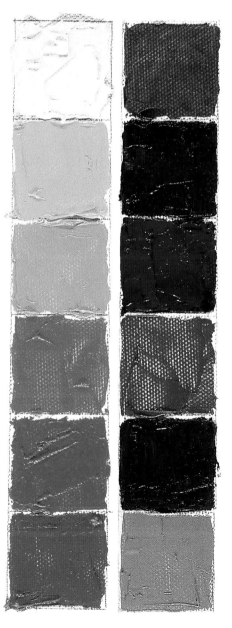

Titanium White
A dense, opaque white.

Cadmium Yellow Light (or Yellow Light)
A transparent, cool, pale yellow.

Cadmium Yellow Medium (or Yellow)
An opaque, warm yellow.

Cadmium Orange (or Orange) Not all tubes are alike in this color. Mix orange from Cadmium Red Light and Cadmium Yellow Medium.

Cadmium Red Light (or Vermillion) An opaque, bright, warm red.

Cadmium Red Deep (or Purple-Red) An opaque, rich dark red.

Alizarin Crimson
A transparent, versatile cool red. Added to white produces a rich pink; to Phthalo Green makes a wonderful black; to Ultramarine Blue + Titanium White, purple.

Dioxazine Violet
A transparent, warm purple.

Ultramarine Blue
A transparent, warm blue. Add Burnt Umber for a good dark.

Cerulean Blue
A warm blue.

Phthalo Green
(or Viridian) A transparent bluish green.

Yellow Ochre
An opaque and very versatile dark yellow.

WORDS TO KNOW

TRANSPARENCY VS. OPACITY
Water-soluble oils seem to have about the same opacity (colors that transmit no light; cover color) and transparency (transmit light; clear quality) as traditional oils. Ultramarine Blue, Alizarin Crimson, Viridian tend to be transparent. The most opaque are Vermillion, Cadmium Orange, Yellow Ochre, Cadmium Yellow Light, Cadmium Yellow Medium.

DON'T SKIMP WITH YOUR PAINT
Artists tend to put out minuscule amounts of paint on their palette. They don't want to waste it. What they are wasting instead is time. You will find that when you want more of the same color that you've already mixed, it will take much longer to match it. Get over it. Squeeze out more paint than you think you will need, then use all of it.

QUICK TIP

LEARN TO MIX WHAT YOU SEE

Every artist sees colors differently and will paint them in a different way. I will teach you how to mix what you see. That is why I stress that you practice mixing your colors and achieving the results that you want. The fun part of painting is making something that comes out of your head. Be inspired by van Gogh. Don't try to be van Gogh. There is only one of him. Allow yourself to be you. You will be much happier with the results.

Yellow Ochre + Titanium White

Ultramarine Blue + Titanium White

Ultramarine Blue

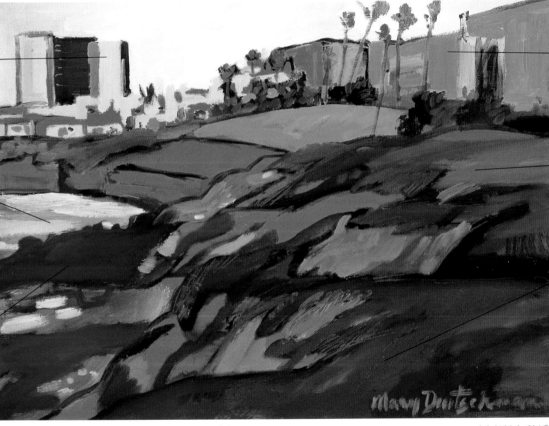

Cadmium Orange

Cadmium Red Light

Viridian + Yellow Ochre

Painting With Colors Straight From the Tube

As the California sun was setting, it spread a warm glow along the coastal cliff and buildings. I described both the strength of the light and my way of thinking about sunsets by using many of the colors from the tubes unaltered. Using your paints this way makes a bold statement.

LA JOLLA CLIFF
9" × 12" (23cm × 30cm)

Mixing Colors

Because manufacturers use different ingredients, paint colors might vary from brand to brand. It is impossible to teach you to mix by a formula. To understand your colors you must experiment. Soon it will become second nature. Just as when you are learning to play the piano, you must practice. When you do, you will automatically reach for the right paint in response to a color.

Mixing Vibrant Secondary Colors

If you are trying to attain the purest, most vibrant secondary colors, you must mix together either two warm or two cool versions of colors.

Mix a red with a yellow in it (Cadmium Red Light) with a yellow with a red in it (Cadmium Yellow Medium). This will give you the brightest orange.

Mix a blue with a red in it (Ultramarine Blue) with a red with a blue in it (Alizarin Crimson) to get the most vibrant purple. Add a touch of white.

Mix blue containing yellow (Cerulean Blue) with a yellow containing blue (Cadmium Yellow Light or Lemon Yellow). This will make an intense yellow green.

Mix Two Colors to Get a Third

Step 1 Squeeze out a dab of Cadmium Red Light and, 1-inch (25mm) from it another of Cadmium Yellow Medium.

Step 2 With your palette knife, join them in the middle, wiping the knife after each use.

Step 3 Blend together to make orange. Don't let the palette beneath show through. It will distort your perception.

Blue-Violet + Titanium White

Vermillion + Ultramarine Blue + Titanium White
Because Vermillion has yellow mixed with blue (all three primaries involved) the result is more subdued.

Alizarin Crimson + Ultramarine Blue + Titanium White
(Produces the most brilliant purple.)

All Reds and Blues Don't Make Purple

Only reds with blue in them (Alizarin Crimson) will work. Mixing a Cadmium Red (or a red with a yellow in it) with blue will produce browns and dull purples. Remember: If you want purple, buy a tube of it or make it with Alizarin Crimson, Ultramarine Blue and Titanium White. This illustration shows some of the different mixtures of red and blue.

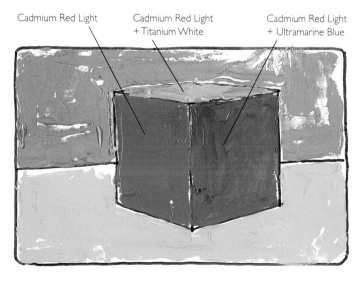

Cadmium Red Light

Cadmium Red Light + Titanium White

Cadmium Red Light + Ultramarine Blue

Paint a Box With Highlight and Shadow Colors

When you have practiced making colors light and dark, do this simple exercise. Draw a 2-inch (51mm) cube with a pen or pencil. Paint pure Cadmium Red Light on the first side. With your palette knife mix a highlight color of Cadmium Red Light and Titanium White for the top of the box. For the shadow color, mix Cadmium Red Light and a little Ultramarine Blue and paint it on the right. Practice this exercise with other colors. Label and save the results.

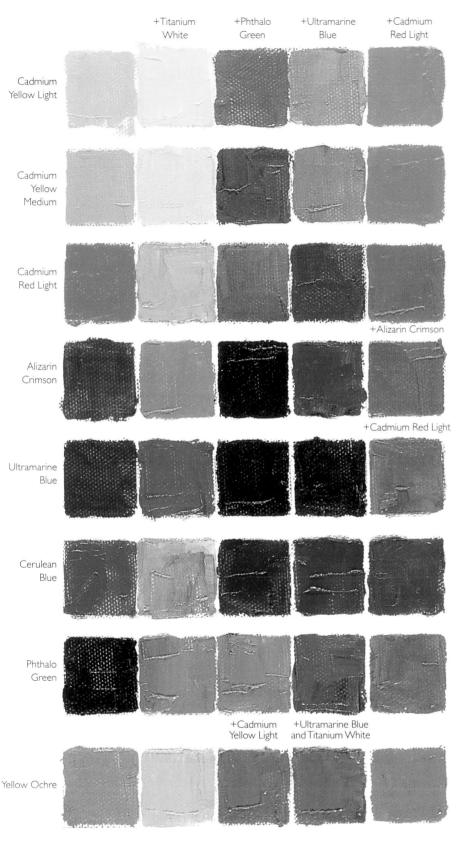

	+Titanium White	+Phthalo Green	+Ultramarine Blue	+Cadmium Red Light
Cadmium Yellow Light				
Cadmium Yellow Medium				
Cadmium Red Light				+Alizarin Crimson
Alizarin Crimson				+Cadmium Red Light
Ultramarine Blue				
Cerulean Blue				
Phthalo Green		+Cadmium Yellow Light	+Ultramarine Blue and Titanium White	
Yellow Ochre				

Mixing New Colors

This chart will help you see some of the possibilities of lighter and darker values. The first column has eight tube colors. They are mixed with Titanium White in the second column. In the next three boxes they are mixed with Phthalo Green, Ultramarine Blue and Cadmium Red Light. There are a few exceptions, which are indicated.

Note that black can be mixed from combinations of Phthalo Green + Alizarin Crimson, Ultramarine Blue + Phthalo Green, or Alizarin Crimson + Ultramarine Blue. There are countless other combinations of the same mixtures. Try to mix some of them yourself. Label them. Keep them in a sketchbook for reference. Practice is the key to learning to mix paints.

WORDS TO KNOW

MUDDY COLOR Colors described as muddy result from mixing together too many colors. You know they are muddy when they turn that yucky-purply-lifeless color.

QUICK TIP

CREATE A REFERENCE CHART FOR YOUR PALETTE

Paint may vary depending on the brand that you buy. Learn about your own paints by making a color chart, like the one on this page, mixing the colors and noting the results to keep for a reference.

The Wonders of Light

Since artists cannot create actual light, they must create the impression of light with color. I always take advantage of sunny days and go outside to take photos. I like either early morning or late afternoon when the sun is low in the sky and is casting long shadows. The light may have a yellow or orange cast, which I find both dramatic and inspiring. It is always better to actually see how the sun hits various surfaces than try to make it up.

Light is also important in the studio. You want good light—the kind that lights your subject, painting and palette. There are many artificial sources of light: lamplight, track overheads, and spotlights. These are more controllable than window light or a skylight. I once had a studio with skylights. They produced very dramatic light for a still life for about thirty minutes a day. Otherwise they played havoc with everything in the studio. You don't want direct light on you or your canvas.

North light is thought to be the most cool, clear and constant. Reflective light is the light from a nearby color. For example, a pear might have some reflected blue in it from the blue plate where it sits.

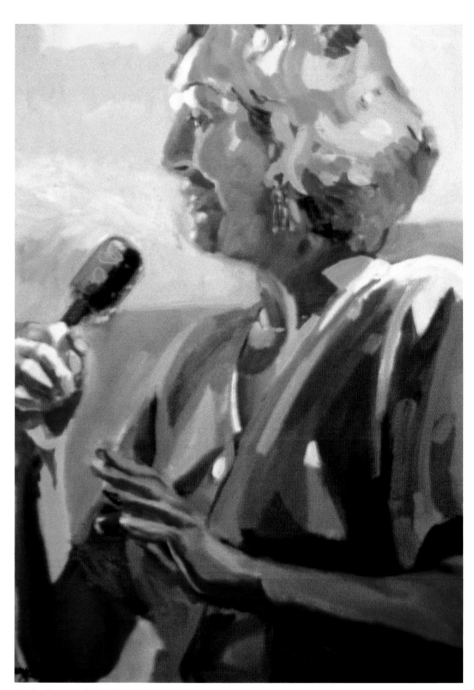

Light From a Window
I had photographed Marilyn many times before as she sang her beautiful jazz songs in dimly-lit cabarets. She agreed to come to my house and sit by the window so I could see her in direct light. I took photographs of her while she sang. I was looking to capture her expression as well as the light.

MARILYN
18" × 24" (46cm × 61cm)

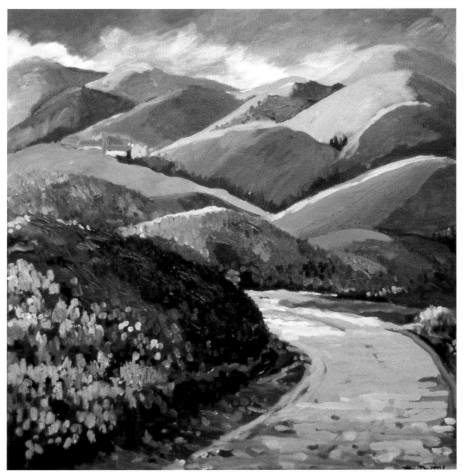

Early Morning Light

Light comes from the left side of the picture and touches the hills and part of the bend in the road. It invites the viewer to take a journey through spring's lush hills in California. When a light color is placed next to a darker color, we notice the light color first. Many people, in viewing this painting, commented on the light above all else.

CALIFORNIA HILLS
36" × 36" (91cm × 91cm)
Collection of Margaret Cantlin

LEARN FROM THE MASTERS
Impressionists broke up light into strokes of color. The viewer's eye reconstructed them to make a whole.

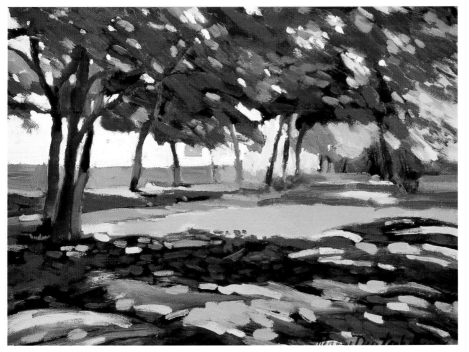

Background Light

The light source is the sky. It illuminates the lake in the background, and filters through the leaves to create mottled light on the ground beneath the densely leaved trees. The grass in the full sun has a yellow cast. It is summer in full glory.

HUNTINGTON PARK
9" × 12" (23cm × 30cm)

The Mystery of Shadow

Shadows are a fascinating subject to study. They can be the backbone of a painting when they form a strong design. When the wind gives leaves motion, they can be spotted and blurry and look like they are dancing. They can evoke images of goblins when you are strolling on a brisk autumn evening.

Shadows can be hard to paint, because they are mirrored shapes of objects such as trees, buildings or people. They are easier to paint when you can actually see them. The result will look more spontaneous. If you are painting trees outside, for example, paint the shadows at the same time instead of painting them as an afterthought. Also, sun or wind may change shadows rather quickly. Take a photo to use for studio reference.

Shadows are not always black, purple or blue. Look closer. Shadows can be made more luminous through the addition of their opposite color. If the shadow seems gray, look again. Could it be painted as a mixture of colors laid next to one another? If you are painting a white hillside in shadow, be sure that the white in the hillside shows through. Mix a little white into the color.

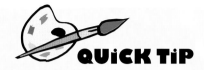

QUICK TiP

STUDY SHADOWS

Put a bottle on a table. Make the room dark. Shine a flashlight on one side of the bottle. Move the light around the way the sun moves through the sky. Observe what happens to the shadow. When you change the color beneath it, some of the new ground color can be seen in the shadow color.

Shadows are Part of the Painting's Structure

The color in shadow comes from the surface (snow), the color of the light source (sky), the color of the source of the shadow (tree), and anything else that might reflect into it (river). That's the reality. Because there is red, pink and orange and green in the picture, I added these colors in the shadows and reflections to keep the eye moving throughout the picture.

BRIDGE OVER WINTER WATER
9" × 12" (23cm × 30cm)
Private collection

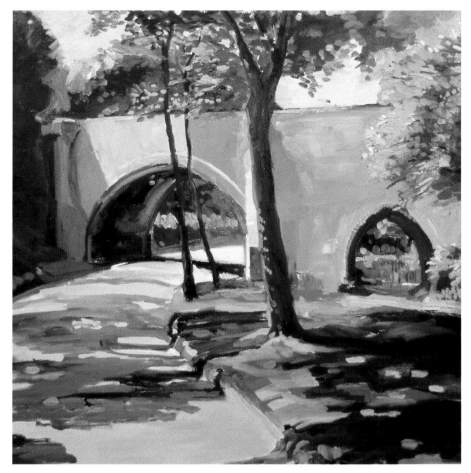

Keeping Colors Moving

The dappled colors woven through the shadows on the grass and road are made from reflections of the things around them. The shadows on the grass are primarily greens (the surface is grass), blues (sky) and yellows (direct light). The road has the same colors, but because the surface is a different color, the shadows have more of a blue tendency. I chose to use yellows on the road because the bridge is made of yellows. Keep the color moving.

BRIDGE IN ROCKEFELLER PARK
40" × 40" (102cm × 102cm)
Private collection

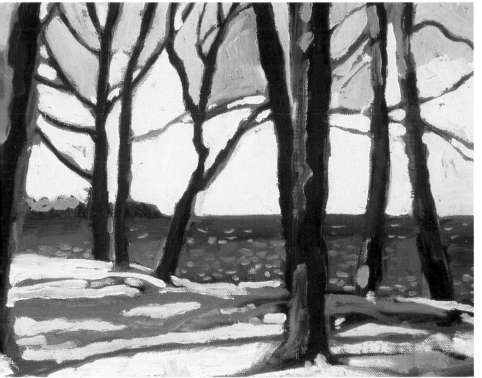

Blue Sky Reflects Into Water and Snow

Look closely. The purple shadows on the snow are dappled with strokes of blue from the sky, making them look as important as the trees. Some of their purple is reflected back into the trees. The orange sunlight gives interest to the cool colors.

 Notice the red ground of the painting showing through around the tree trunks. I painted the canvas with a diluted Cadmium Red Light paint and let it dry thoroughly before I started the painting. Covering all of the red would have destroyed some of its energy.

TREES IN PARK WITH SHADOWS ON SNOW
9" × 12" (23cm × 30cm)

Identify Color With a Spot Screen

Colors can be identified much more easily when everything else around it is blocked out. The spot screen is a tool you can make to help you. From then on it's simple. Name the color that you see. Mix the paint. Match the paint to the color spot.

MATERIALS

SURFACE
Index card

WATER-SOLUBLE OILS
Various colors from your palette

OTHER
Palette knife • Paper punch • Scissors

1 Make a Viewing Tool
Cut a 5" × 8" (13cm × 20cm) index card in half. Each half will be 4" × 5" (10cm × 13cm). With a paper punch, make a hole in the middle, near the top. Hold the card at a relaxed arm's length from your eye and look through the hole at the color that you want to identify. Now that color is isolated and the rest of the colors are blocked out. Name the color that you see through the hole, for example Cadmium Red Light with a little Ultramarine Blue to make it darker.

2 Mix the Color
Mix the color that you see with the corresponding paints on your palette using your palette knife. Put some of the paint on your palette knife and hold it next to the hole focused on the subject.

3 Match the Paint Mixture to the Subject
Does it match? The process is much the same as matching fabrics to a color swatch. You will probably have to adjust the paint to get it right. Try to get the value right. If the color isn't perfect, that's OK.

QUICK TIP

PAPER PUNCH
A paper punch (shaped like pliers) has scissor handles and punches a single ¼" (6mm) hole. Buy one at your office supply store. It will last a lifetime. In addition to punching cards for spot viewing, it is perfect for punching holes in gift tags that hold ribbon.

Paint an Orange

You can discover a lot from painting a fruit still life. What could be more convenient? A still life is right there in front of you, it doesn't move or get tired, and you can control the light. There are also many visual similarities between fruit and people. People are convex, except for a few having sunken cheeks. Seeing their roundness is important. Their skin may have an olive or peachy cast or be wrinkled like a dried apple, but we won't go there.

MATERIALS

SURFACE
Canvas Paper
(work in a 4-inch
[10cm] square area)

BRUSHES
1-inch (25mm) flat • No. 6 filbert

WATER-SOLUBLE OILS
Cadmium Orange • Cadmium Yellow Medium
• Dioxazine Purple • Titanium White •
Ultramarine Blue

OTHER
An orange • Blue paper • Jar of water •
Palette Knife • Paper towels or facial tissues •
Lamp

1 Paint the Foundation and Shadow
Cover the table with blue paper. Set your orange on the tabletop. Position the lamp above it at 45 degrees so the light hits the orange on one side and casts a shadow on the opposite side. Mix a small amount of Ultramarine Blue into Titanium White with your palette knife. Use your brush to cover the background square with a very thin layer of light blue. Let it dry. Draw an outline of the orange with Ultramarine Blue. Paint the shadow with the same color. Look at the color of the shadow on the orange with your spot screen. Name the color. Mix a little Ultramarine Blue into Cadmium Orange and paint the part of the orange that is in shadow.

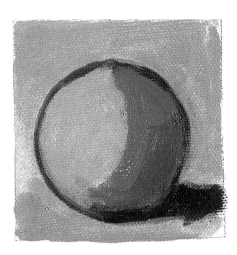

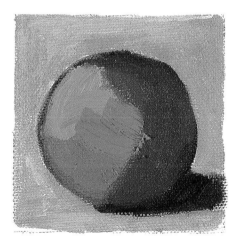

2 Determine the Other Values
With the spot screen, look at the side of the orange that is not in shadow. Simplify that area into two colors. Mix those two colors: Cadmium Orange and Cadmium Orange + Cadmium Yellow Medium. Paint those two areas, wiping and rinsing your brush each time.

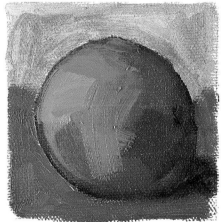

3 Paint the Background Colors
Look through your spot screen at the blue paper to find your value for the upper and lower backgrounds. Mix Ultramarine Blue, a little Dioxazine Purple and Titanium White to find a value that is close. Paint that lower area. Add more Titanium White to the Ultramarine Blue for the lighter value.

Different Palettes

When you speak of a *high-key* painting or a *low-key* painting you are referring to the values of the dominant colors. A *high-key* painting is made up of mostly light values (light blue, pink, yellow, aqua, lavender, beige, white). A *low-key* painting is mostly dark, subdued, somber, nighttime values (dark green, purple, dark blue, brown, dark red). A *middle-key* painting uses the entire range of tones. You are likely to find a *middle-key* scene on a bright, sunny day, in a place with trees that cast dark shadows or buildings that are in shadow. The grass in the sun is bright green while the other part in the shadow is dark green. Which one do you use? That is up to you. You are the artist. How do you feel? Sometimes the weather or location will dictate the key. Think of a yellow ball lying on a sandy beach on a sunny day (high-key) or a dimly lit street with dark houses (low-key).

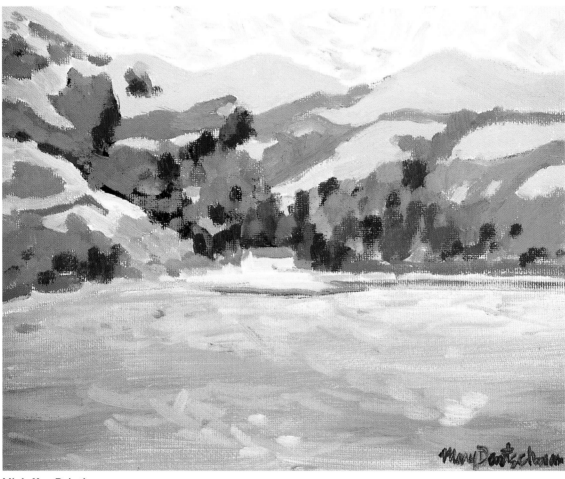

High-Key Painting

These swatches of light value make this a *high-key* painting. When you are working on a *high-key* painting, keep almost all of the values in the upper range. It is still possible to have some contrast, but in this Mediterranean-type of sunlit area, most of the darkest foliage can be rendered in a medium value.

SUNLIT HILLS
9" × 12" (23cm × 30cm)

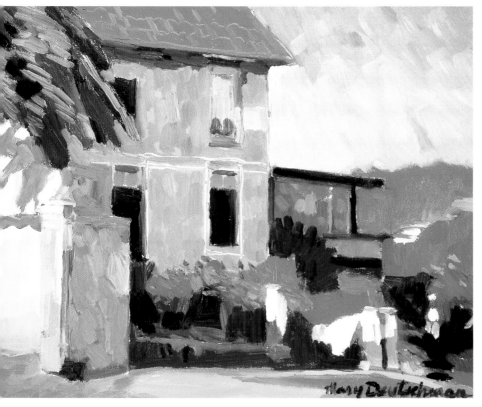

Middle-Key Painting

There are clearly *high-key*, *middle-key* and *low-key* values in this picture, but most of them lie in the middle range. The same scene could have been painted when the morning sun warmed the house in the front. Since it was in shadow, I chose to give it more color by adding warm reflections to the cool color of the shadow, a color that I borrowed from the roof.

FOLKS WHO LIVE BY A HILL
9" × 12" (23cm × 30cm)

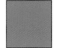

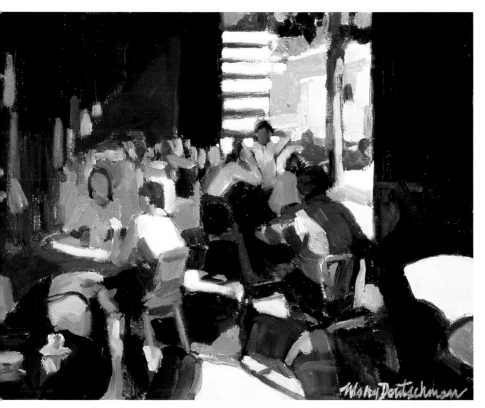

Low-Key Painting

It was a very sunny, hot day outside of an art museum café in San Francisco. I worked from a photograph that read the light inside as a dark area. Compared to the outdoors, the inside did seem cool. The light from inside came from late afternoon sunlight describing bare arms and sunlit shirts. The rest was dark. It was unfamiliar ground for me. I felt free to portray the people without detail and as part of the design, which is as I believe it should be.

WHERE THE ART LOVERS MEET
9" × 12" (23cm × 30cm)

Approaching Your Subject

Your subject can be a landscape, a group of people engaged in an interesting visual relationship or a colorful building that stands out beautifully against the blue sky. When choosing a subject, it is best to have a method to find out what really works. Before you actually spend time painting, try some of the ways to test your idea. You will find that some subjects work better than others.

Your preparation will make you understand your subject more thoroughly. The best reasons for doing preliminary work are to learn, to have fun, to feel free expressing yourself and maybe go beyond the boundaries that you spent so many years weaving for yourself. It is important to free up some of the memories of those voices that said you must paint or do art in a certain way.

Some of the best work that I have judged in shows was from preschoolers. You know, the little people who approach art with a smock and a brush as long as their arm full of all of the paint it will hold, who jump about, throw the paint around and do a piece of art that brings tears to your eyes. Their work is totally unencumbered by years of hearing what art should be. They just do what happens, and that's exactly the way it should be.

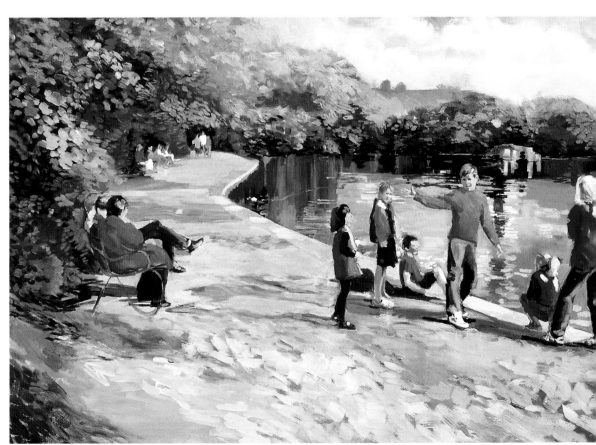

CHILDREN OF DUBLIN
48" × 72"
(122cm × 183cm)

Gather Information Using Photographs

My husband and I have traveled a lot. Not always having time to paint things on location, I developed the habit of carrying a camera and sketchpad with me. After many years, I learned to take pictures that were good references. When the subject matter suits my fancy or I am drawn to the way the sunlight falls on the garden, or when the clouds in the sky are billowy or dark and brooding, I take a snapshot. Photographs are the first step you will use to gather information and become familiar with your subject.

Getting Good Reference Shots

Shoot a subject that appeals to you. There are many ways to configure a photo, but make sure to compose it in the camera viewfinder so that it has a strong design.

- Look for perspective.
- Try not to divide the picture in half either horizontally or vertically.
- Don't put a horizon in the middle.
- Look for light and shadow and the patterns they make.
- Take several angles: a close-up for the detail and a few consecutive shots so you can tape them together for a bigger, more detailed reference.

Photographing People

Take your camera outdoors on a sunny day where you will find more subjects than you can imagine. Go anywhere that you might find people. The beach is a wonderful start. If the location or season is wrong for a beach, try taking that camera to sporting events, parades, the mall, dance classes, etc. If you want to look less obvious, use a long lens. Here are three things to keep in mind when photographing people.

Groups of People Take several pictures of the same group. Because they are moving, it takes practice to click at just the right time.

Interesting Light When the sun hits part of the body or face directly and leaves some in shadow, you can create more drama.

Action A person in motion is much more fun to paint and gives your painting more energy.

Four Horizontals, Two-Over-Two
I was so excited about taking this photo that I shot the upper right one on an angle. It's not a problem. Just tape it together the way it works.

Three Horizontals
This panorama will make a great reference for a diptych (one painting done on two canvases).

QUICK TIP

FRAME YOUR PHOTO
Allow more space in the photo than you need. Zoom out just a bit to allow all objects that you might want for reference to be included.

Two Verticals Side by Side
I had a difficult time shooting these black-eyed Susans in a single shot. I wanted the flowers bigger. The result was inspiring.

Composition Basics

Composition is the act of putting together shapes and line in a pleasing way to make a whole. Design is a plan for composing. It is the foundation or structure of a work of art that gives it visual balance. The arrangement doesn't need to have color, texture, or value. These elements make a work more complex.

When you paint landscapes, you usually have to work with predetermined elements (trees, barn, hills, etc). You can use or eliminate some of them or you can rearrange them in a way that is pleasing to your eye. In a still life, the elements are our choice and you are free to arrange them as you wish.

If you are painting people, you can determine the pose and the way that the figure is cropped to ensure a good design. If your design is not well done, then stop. Get it right before you paint. Doing sketches in pencil and pen will help you decide whether it will work. Keeping the basic rules of composition in mind will guide you.

Negative Space

Negative space is, for example, the space between the branches on a tree where the sky shows through. Make the edges part of the design. The four sides of the composition are as important as anything else inside. If it's a tree, allow the branches to go off the edge. It will create additional negative shapes to enhance the design. Try painting the negative space that you see before you do the rest of the painting.

Lead the Viewer's Eye

Create movement and direction by using a river or road or path in you picture. Curves have more appeal than a straight road. Look closely at the perspective. Be sure the road is wider on the bottom and gradually smaller where it leaves your sight. Think of a railroad track becoming smaller as it goes away from you.

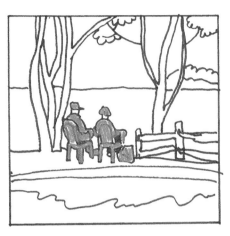

Center of Interest

Placing a figure near the center of the picture (near, not directly in the center) will draw the viewer's eye to it and create more interest. Decide what you want to become the subject of your picture and then design it accordingly. Figures are good focal points.

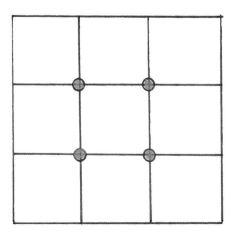

Rule of Thirds

Divide any space both vertically and horizontally in thirds. Where those lines intersect, you have what traditionally are called *Golden Points*. Your subject should touch one of these. It will not necessarily mean you have made the most interesting composition. Think of it as merely a guideline to check whether your design is acceptable. Good design is intuitive.

Don't

The balls sitting on a line equally spaced and all the same size is not displeasing to view but not very interesting, either.

Arrange objects so they aren't all the same, not straight, not equidistant and all pointing the same way.

Do

Draw your elements closer to the center. Try to group them to create a very strong element. Consider putting them into motion. Make one or two bigger than the rest.

Use Design Principles to Plan Your Painting

Painting is not about trying to replicate an object. It is about breathing your own creativity into the entire canvas. It is using a scene for inspiration, carefully rearranging it, giving it another color or making the objects bigger or smaller to suit your needs. This arrangement of the elements in your painting is the design or composition.

Design has many characteristics: balance, rhythm, proportion, direction, size, shape of lines and the forms that these lines create. Walk through a museum and view each painting solely in terms of design. If one catches your eye, try to decide which of these elements might be the reason.

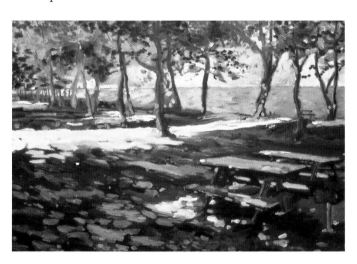

Rhythm and Movement

The trees bend with the movement of the wind, changing the shadow patterns of color on the grass and picnic table. Use strokes of color representing shadow and leaves to give the feeling of movement.

HUNTINGTON PARK PICNIC
36" × 48" (91cm × 122cm)
Collection of Mr. Jess Sellers

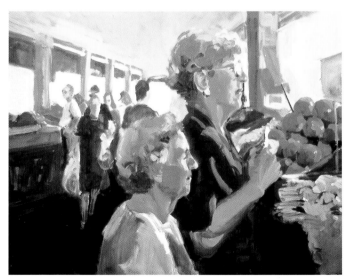

Strength in Togetherness

These figures are grouped together to form a strong design element. The dark and light areas of ceiling and floor that surround this group are strong negative spaces. The fruit on the right and left sides draws the eye to the edges.

LADIES AT THE MARKET
30" × 40" (76cm × 102cm)

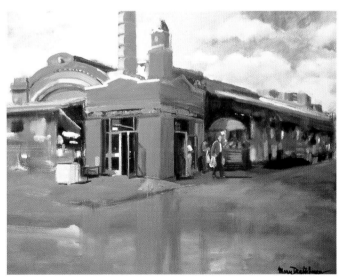

Color Strengthens Design

The focal point is huge. The rain from the night before, still in the street in front, inspired me to bring the reflections in the orange color to the bottom of the canvas. Now the subject, the building, looks even stronger.

THE WEST SIDE MARKET
30" × 40" (76cm × 102cm)
Collection of Mr. and Mrs. Bruce Murray

Sketch Your Subject Using Pencil

Sketch everything. Look for proportion and shapes, and how they relate to each other. When I have the time, I do sketches with written notes. Do several sketches of the same scene, then choose the best. They need not be large. Small ones usually make the best kind. They are easier to do and allow you to see a more general picture. Avoid too much detail, as it will make you lose some of your freedom in the final rendering. Carry a sketchbook everywhere. Take it to the beach and note the masses of flesh and the shadows people in swimsuits create. Look for a group under an umbrella. On a car trip, do fast sketches of the road before you. Keep your eye on the subject and don't worry about the lines. In airports and waiting rooms sketch people in relaxed poses. In a restaurant, sketch people engrossed in their meal or each other.

Most of my drawings are done with either a Design Ebony or 6B pencil; either is soft enough to make a nice heavy line without too much effort. Pay close attention to your composition from the beginning of your painting process. Look for negative space. We see this space everywhere. The edge of your painting will make negative shapes by interacting with positive shapes that touch it.

MATERIALS

SURFACE
Index card or sketchbook

OTHER
6B pencil or Design Ebony

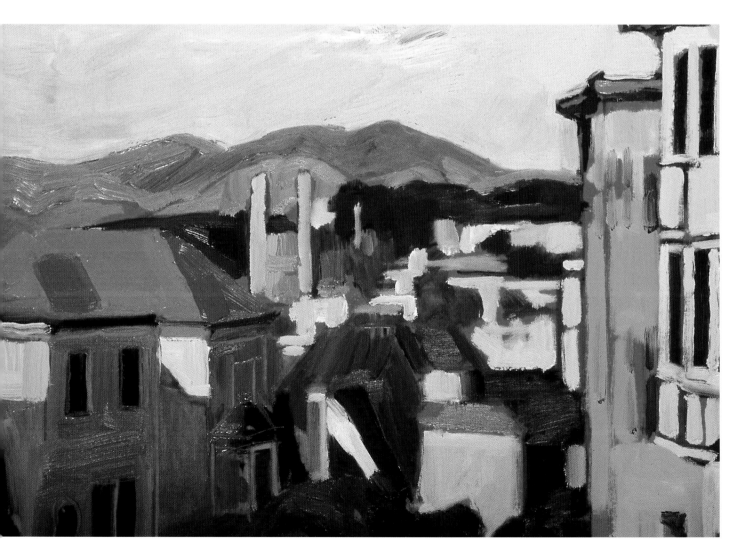

SAN FRANCISCO CASTRO
12" × 16" (30cm × 41cm)

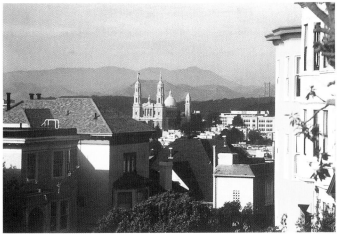

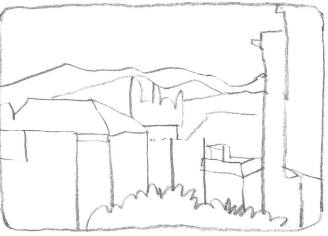

1 **Take an Inspiring Photo**
A photograph is a wonderful reference for a sketch and a painting. You will see more contrast when the sun is creating obvious areas of light and dark. Photograph late in the day when it casts a golden hue on buildings.

2 **Sketch Simple Shapes**
Look for simple shapes (like rectangular buildings) to help you see your subject. Outline the main areas before you add darks or lights. In this case, it is the bushes in the foreground, hills and buildings.

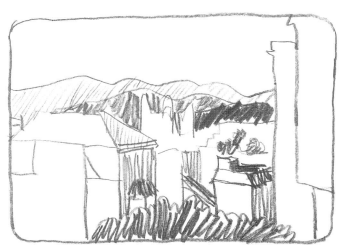

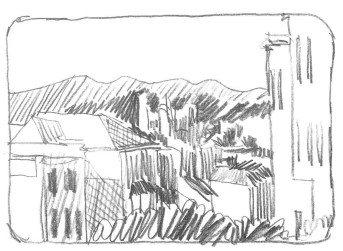

3 **Work From Dark to Light**
Add the darks first. They will be part of your composition structure. Next, add the medium values. Work with bold lines for the darks. Lines close together look dark. Lines that are farther apart look lighter.

4 **Add the Lights and Detail**
Add light lines for the lightest areas. If they seem too much like the medium lines, crosshatch the mediums to see the difference in value. Add some detail to remind yourself what you want to show. Always think of your sketch as a plan.

Sketch Your Subject Using Pen

If you like to sketch with a line that is crisper, more black and more definite than a pencil, a felt-tip pen is for you. It is easy to use for sketching when you are away from your studio because it doesn't have to be constantly sharpened. In advertising design, a juicy pen with a sharp point always made my day.

The process of making a sketch is similar to making a pencil sketch. Hold the pen loosely. Move your arm, not just your hand. Even if you are working outside, take a photo for more reference. You might want to do a bigger painting of the subject, and you will want all the reference that you can get.

MATERIALS

SURFACE
Scrap paper

OTHER
Felt-tip pen

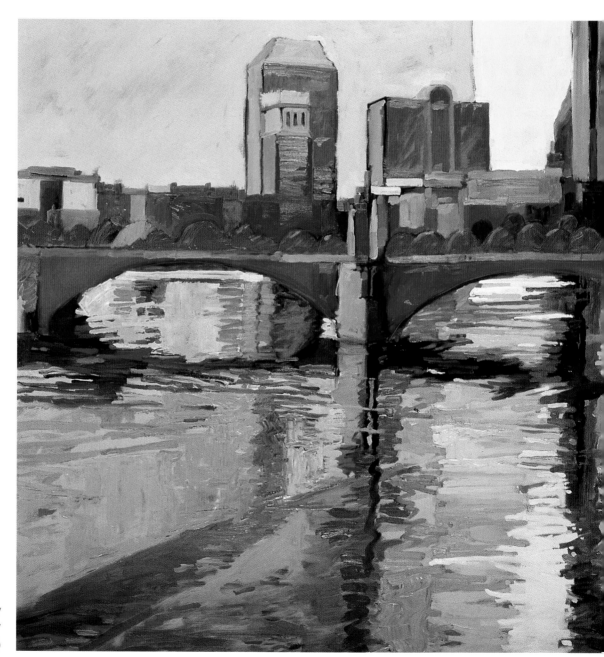

BOSTON BRIDGE IV
40" × 40"
(102cm × 102cm)

QUICK TIP

DRAW AS MUCH AS YOU CAN!
You will get better every day. Observe as much as you can.
It will improve both your drawing and your memory.

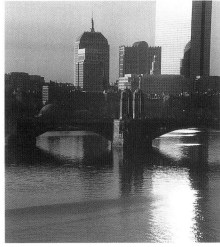

1 Begin With a Photo
I liked the strong design of this scene with the bridge and the buildings making strong horizontal and vertical directions. I chose to make a composition with a square shape, in keeping with a series of bridge paintings that I was doing. You might prefer a horizontal shape.

2 Draw the Outline Shapes
Outline the bridge and buildings. Look for basic shapes like rectangles, triangles, squares and circles when you draw. The under edge of the bridge takes the shape of part of a circle, an arc.

3 Add Strength by Adding Darks
Dark areas are building blocks for your picture. Make the darkest areas, the bridge and sides of the buildings in shadow, by drawing heavy lines close together. Make the sky and some of the reflections with lighter strokes that are farther apart. The result will be a medium shade.

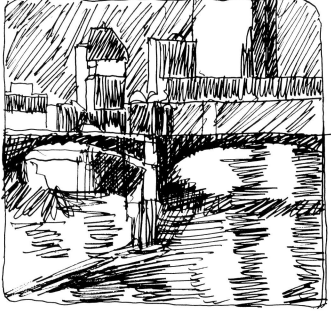

4 Target the Reflections
Add the rest of the medium values in the reflections and shadows above the bridge. Because there are so many medium values, don't shade the light values; this denotes a very light value. Capture the feeling of the reflections by making them with quick, moving strokes.

Plan Your Colors Using Oil Pastels

Oil pastels can be a very inspiring, quick way to find the right colors for your painting. No squeezing out paint, cleaning brushes or preparing canvas. Just let your ideas fly. You can do several color sketches in a few minutes. Because they are done quickly, they will show you a creative way to distribute your color.

Learn to mix colors and values with oil pastels. Try them over solid color. Use the edge of the stick for a sharp line. Make strokes of yellow or white over a darker color. This both blends and lightens. When your paper won't hold any more pastel color, remove part of it with the end of a palette knife by scraping or hatching. With a cotton swab dipped in turpentine, Liquin or vegetable oil, move the colors around to blend. This will give you a painterly effect. However you handle the colors, regard them as a way to express your sense of color. This is not the time to hold back.

MATERIALS

SURFACE
5" × 8"
(13cm × 20cm)
index cards

OTHER
Assorted oil pastels • Camera • Cotton swabs
• Liquin (or substitutes)

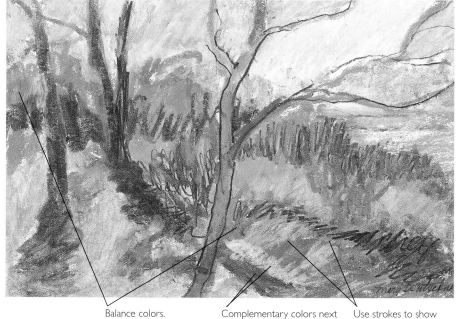

Balance colors.

Complementary colors next to each other are synergistic.

Use strokes to show movement.

Reference Photo
I was attracted to the strength of the composition of this place in the park. The position of the big trees is the most compelling part. The diagonal made by the grasses is strong as well.

Color Plan
I did a pencil sketch and later decided to add pastel. There is not much detail shown. It was a plan for the color. Think of design and color. Use your strokes to show movement (the grasses). Keep your color balanced. Use complementary colors (red and green, orange and blue, yellow and purple) to create energy.

Yellow patches show sunlight streaming through trees.

Foliage made by yellow and blue strokes instead of green create movement.

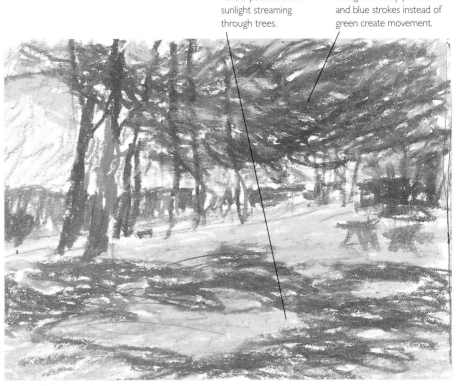

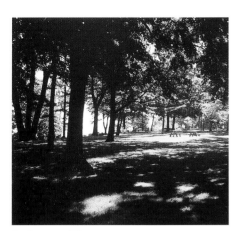

Reference Photo

The park has many trees that are set in motion from the breeze that comes off the lake. When they move, so do their shadows.

Color Plan

I wanted to capture some of that motion with my pastel strokes. I made the strokes fast. The leaves could be seen as one moving element. The shadows had another way of acting. Their most noticeable motion revealed patches of bright green grass.

Exaggerate the figure leaning into others. This gives the painting motion.

Fast strokes convey the feeling of energy.

Express the light source in yellow.

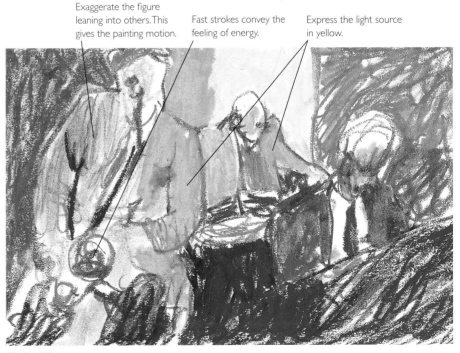

Reference Photo

The subject of Jazz Musicians allows a great opportunity for letting loose and being creative with color and showing lots of movement and spirit. Think color as well as design.

Color Plan

The photo I took already set up the composition. This was the time to play with the color. Let your strokes be free. Choose the most exciting colors you have. Use complementary colors side by side to make the result as vivid as possible.

Plan Your Colors Using a Computer

A variety of computer color programs can make your use of color more spontaneous. I use my Corel®Painter™ program both to get started and to do several versions of a subject so I can choose the best. It is a great tool when I am in the middle of a painting and have lost my way and need to experiment with the color. I photograph the painting with my digital camera and have access to the program immediately. After the digital file of the design is in the computer, choose a brush size and shape. Then choose a color and place it inside the area that you want to paint. If you decide to use another color, paint over it.

MATERIALS

SURFACE
Sketchbook or index card

OTHER
Computer paint program • Felt-tip pen or 6B pencil

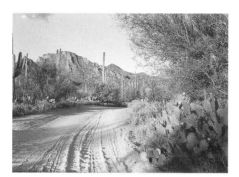

1 Reference Photo
It was late in the afternoon in the Arizona desert. Long shadows crossed the sandy road. The mountains and saguaro cacti were tipped in golden sunlight. It was a beautiful and quiet part of the desert. The photograph was an inspiration. I wanted to make the focus the saguaros and mountains, so I changed the composition.

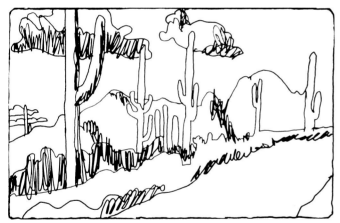

2 Plan Your Composition With a Pen Sketch
Using a felt-tip pen (you can also use a pencil), I composed a slightly different perspective, but used all of the elements on the left side of the road. Using a pen makes a clean, readable line.

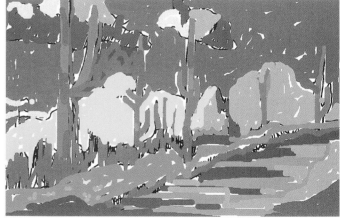

3 Plan Your Colors
I scanned the sketch into the computer and played with the colors, changing them from time to time, until I was pleased with the result. When I used a color in one place, I used it in several other places to draw the eye of the viewer throughout out the picture. This is important when painting.

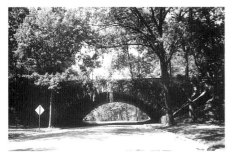

1 Reference Photo

I began with a photo of a bridge that had been an inspiration for several paintings. From it I did a simple outlined pencil drawing. Playing with the color yielded three extremely different but very colorful results.

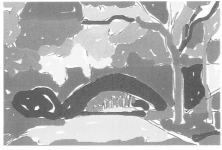

2 Choose the Base Colors

I wanted to use my color to the fullest. Corel®Painter™ has about one hundred colors from which to choose. This experiment was strictly about color shapes and using color to its fullest. I added no detail. I worked with the big brush (on the computer, this is a circle that acts like a brush).

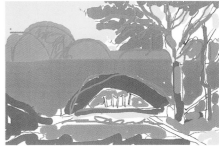

3 Add Details and Additional Colors

A portion of the sky became solid yellow. I used a medium brush to fill in smaller areas and a very narrow brush to draw lines. The trees above the bridge are solid green but have a blue line running through them.

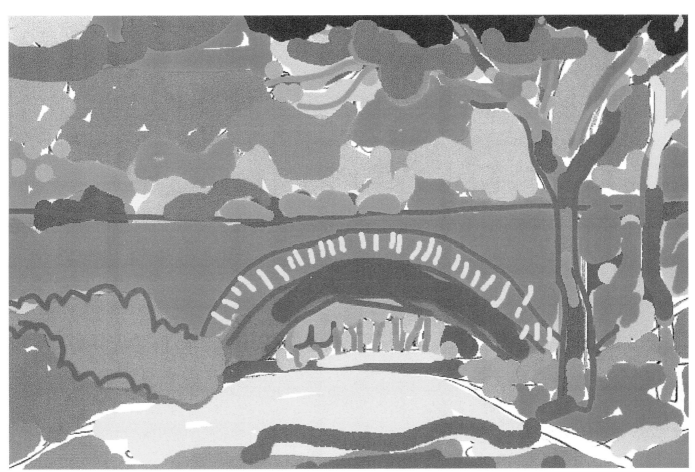

4 Refine the Details

This time I added more detail, like the lines around the bridge opening. While it is never necessary to have detail, I felt it would bring the color from one side to the other and I wanted to remember to include that idea in the painting.

Where to Paint

Painting Outside

If you have never painted outdoors, you are missing a whole different way to approach a painting. The experience will certainly add a wonderful energy to your painting. I teach classes outdoors where life is not always ideal. We wear parkas, scarves, and gloves and sit beneath shelters to stay warm and dry. Wind is always a factor. Easels blow over, paintings become airborne, weights are placed on everything but the students. If you don't like the weather, go another day, but go.

Since light is not predictable or controllable, you must work quickly. This gives you a good sense of excitement that will translate into your painting. You will experience the great outdoors with more than your sight. You will feel the wind, smell the flowers, hear the sound of waves crashing against the rocks, and taste the salt air. These things will, in some way, give your paintings a sense of having been there. Find a scene that you like. Take a photo. If you know you have time, do a sketch as well. It may just lure you into doing the painting there instead of going on to something else.

Painting Inside

If you prefer the comforts of your studio—out of the cold, heat, view of the onlookers, wind—where you can listen to the inspiration of your music, have your lunch, fresh water and your facilities, then capture your subject all beforehand with a sketch and a few photos.

Painting in your studio, if there is no one or nothing to disturb you, can be a very productive experience. Turn off the phones, fax, and computer. Open the doors if weather permits to hear the birds, waves splashing on the shore, or wind in the trees. If the outdoor noise is screeching brakes, honking horns and police sirens or arguing neighbors, do yourself a favor—close the doors and turn up your favorite music. This is your space and your time; don't allow it to be taken away.

WORDS TO KNOW

DIPTYCH One painting done on two canvases or any piece of art done in two sections meant to be shown side by side.

Painting In Your Studio

Your studio is a perfect place to paint a big canvas. I painted these canvases on two easels side by side. From the window, when the late afternoon sun is extraordinary, you can see palm trees blown by the ocean breeze, the energy of the ocean and the downtown buildings lit by the warm, golden sun. Some places just don't get any better.

VIEW FROM LAJOLLA MUSEUM
36" × 72" (91cm × 183cm)

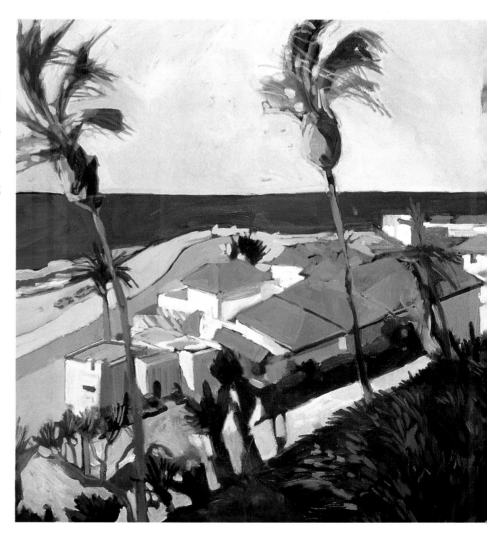

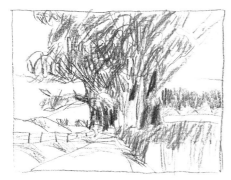

Create a Value Sketch

After you have found a place outdoors that you find engaging, take some reference photos of the precise angle that you like. Begin with a pencil sketch to test the design on paper. Think in masses of darks and lights. Working in black-on-white will quickly identify the areas of light and dark. Without color, value becomes everything. If your first sketch does not work out, try another.

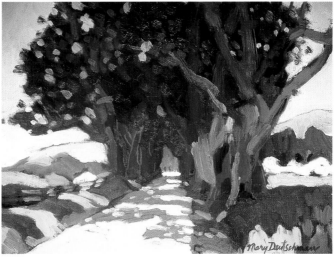

ARBOR IN CALIFORNIA
COUNTRYSIDE
9" x 12" (23cm x 30cm)

Finished Painting

Begin with one color and a medium size brush. Draw the same scene not from the sketch but from the landscape once again. Learn more from it. Clean your brush and begin to put down the darkest greens, then with a slightly smaller brush, the medium and light greens. Try Blue-Violet and a little Titanium White for the tree trunks, and add Yellow Ochre where the light hits. Keep thinking in terms of a mass of trees or one unified color.

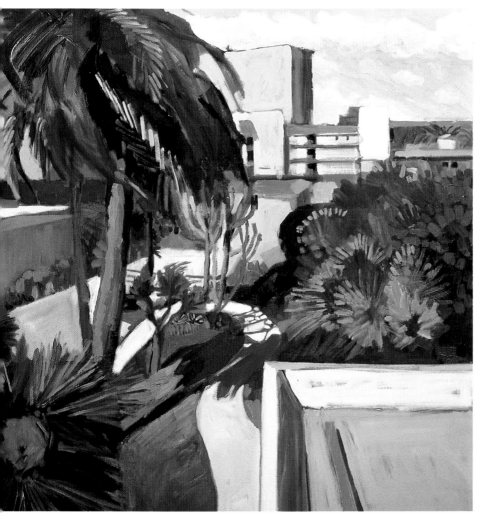

The Picture Perfect Viewfinder

When you look at a scene outdoors, you see too much at one time. A viewfinder, or spot screen, will help you focus on the parts you want to paint and block out the rest, just as the spot screen helped you isolate one color from the others surrounding it. You can make your own (page 34), but this comes with so many features that it is hard to resist. In addition to representing standard frame proportions divided in "thirds," it has a value scale and red film to make the values easy to read.

Still Life

Still life painting has been a favorite of artists for centuries. I must say, it is a favorite teaching method of mine. Define it quite simply as subject matter that interests you, arranged in a pleasing way and lit with a single light source. Still life painting has advantages over painting outdoors, where the light and weather are always changing. It does not vary from its pose or need a break like a model in a portrait. You can paint in the comfort of your studio, have complete control over your subject, and the option to abandon it for a day or two to visit a museum.

Visiting a museum is a perfect opportunity to learn about design, color and shape. Take advantage of any opportunity to study still lifes there. Many artists chose to paint colorful fruit (Cézanne, Caillebotte, Gauguin). Some painted flowers (Manet, Monet, Renoir). Others chose boots and books (van Gogh). Some chose game birds (who apparently lost the game). I must say that this would not be my choice.

SALLY'S STILL LIFE
18" × 18" (46cm × 46cm)

Choosing Subjects

What to paint? Don't agonize. Painting is about how you paint, not what you paint. Through practice, you will find your own way, which will be different from mine, Monet, and that fabulous artist you saw in a New York gallery. Just as your handwriting eventually becomes distinctive, your art style will also become what is you.

Subjects for still lifes are easy to find. Go through your house and select everyday, familiar objects that you like. From the kitchen you can use mixing bowls, dishes, colored napkins, glasses, pitchers. From the pantry and refrigerator, fruit, vegetables, wine bottles, cheese, and bread. Move on through the house. Use some gardening tools or one of your potted plants. (Garage sales are full of things to paint.) Bring some of your selections into your painting area and arrange just three or four together.

Set up something simple. You can compose a beautiful still life with just a few, well-chosen objects. You are more likely to want to paint a subject when it is not overwhelming. You know you have chosen well when you find that the negative space of the props and their shadows produces an eye-catching design.

Simple Subjects
Vegetables and fruit can be wonderful subjects by themselves. Peppers are a shapely and colorful vegetable to paint. For variety, cut one of them in half or place them in a bowl. No matter what your subjects are, let them relate.

THE COLOR OF PEPPERS
9" × 12" (23cm × 30cm)
Collection of Sally Nagele and
Jon Schurmeier

Incorporating Color
A colorful ceramic piece from our travels inspired the focal point of this setup. The fruit and fabric continued the colorful theme, and the strong lighting added the feeling of sunshine. Painting some of your souvenirs can add to your memories.

COVERED POT FROM PORTUGAL
WITH FRUIT
9" × 12" (23cm × 30cm)

Arranging Your Subject Matter

To select items for your painting, look for simply designed things and select just three at a time to start:

Variety in shapes Tall pitcher, a bowl, or an apple.

Compatibility in color For example, select items with blue, orange and white.

Similar theme Gardening: a clay pot and gardening gloves, or enjoying a snack: an apple, dish and knife.

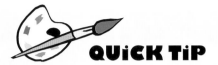

QUiCK TiP

START OUT SIMPLE

Paint simple setups until you feel comfortable. Then add props to your still life to give it a feeling that something is going on there (like a dish, knife or cup). It will get viewers involved and they will spend more time looking at it.

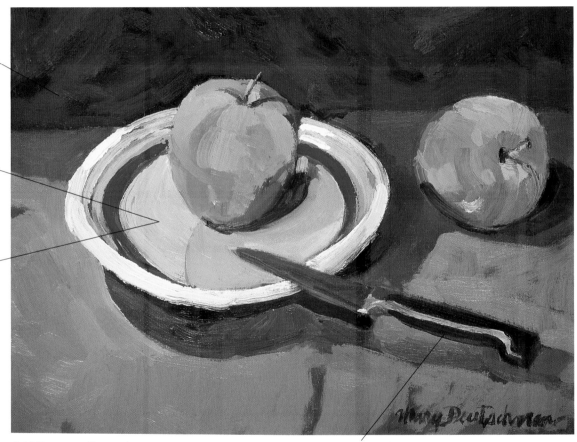

I chose the green background because it is the color complement of red and the two colors intensify one another.

The plate gave a feeling that the apples might be served later.

The plate was white; I added Yellow Ochre so it would not be the focal point.

Add Props to Create Interest

TWO APPLES WITH A PLATE AND KNIFE
9" x 12" (23cm x 30cm)

The knife added a strong diagonal for drawing the eye to the apples.

Creating a Background

I have seen many students put so much effort into painting the objects in a still life and leave the background white because they did not know what to paint. You will have far less difficulty making this decision if you give it some thought in the sketch stage. At that point, it is not too late to move the objects to the left or right to make the whole design work.

Backgrounds can be light or dark, and made up of heavy strokes. They can be part of the room that is actually behind the still life, something you make up, or an arrangement that you set up.

Geometric Shapes

A background can be an area of two or more colored shapes (rectangles, squares, circles, triangles) that work with the props. Their colors might be a repetition of what has been used in the props or colors that complement them.

One-Color Background

Many artists (Manet, Fantin-Latour) chose to make their backgrounds very dark. Dark colors look very dramatic and most certainly draw your eye into the focal point. Red or blue (Gauguin) are great choices for this. Pick a color that you will repeat in the rest of the painting.

Heavy Strokes

Backgrounds can be made from strokes of heavy paint. Look at van Gogh's sunflower paintings. Make the strokes thick and juicy. Let them show a movement of air.

Paint the Scene Behind the Setup

Make your painting look like a room. Use the background that you see, or add something like a table and chair (Cézanne). Drape fabric behind the setup. Let the background look like a window or door or a picture hanging on the wall. The rest of the wall can be patterned wallpaper or a solid color (Cassatt).

Composing a Still Life

Take a drawing or a photograph and move your cropping tool (page 106) over the surface until you find a small area that appeals to you. Write down what you like about its design. Move the cropping tool again and find another area that you like. Write down what you like again. Keep doing that until you have eight or ten descriptions of what you like. Some of the elements that came to my mind when I did the same were: movement, drama, horizontals interacting with verticals, nice grouping of colors or elements, interesting negative space and rhythm.

When you have some sense of what appeals to you, cut out basic shapes and compose a design, trying to use some of the elements that you like. Some of the designs that you create won't seem to work, some will. When you can recognize some of the differences, you are learning.

MATERIALS

SURFACE
Construction paper

OTHER
1 oil pastel color
3 different colors
of construction paper
4B or 6B pencil
Cropping tool
(page 106)
Glue stick
Scissors

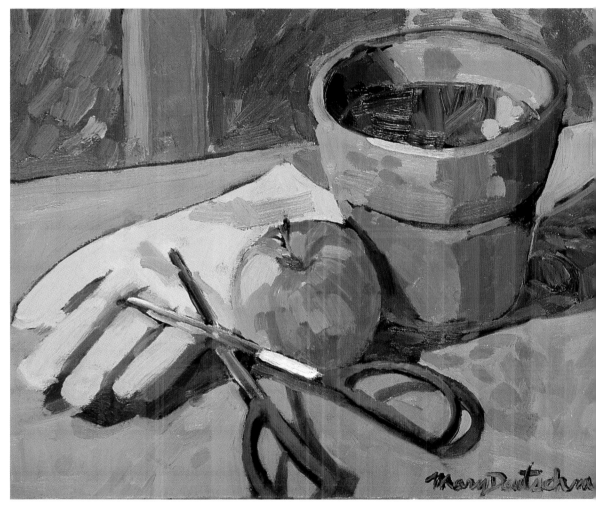

Finished Composition
Working back from this piece, you will see how I came up with the composition for it.

GARDENER'S TOOLS WITH APPLE
9" × 12" (23cm × 30cm)

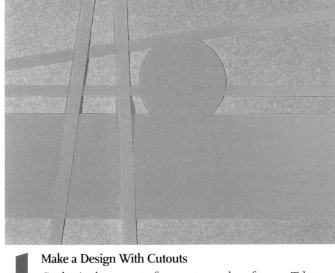

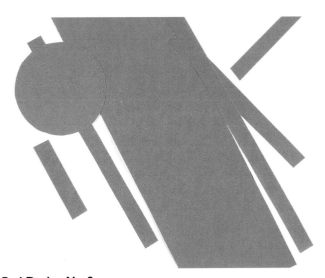

1 Make a Design With Cutouts

Cut basic shapes out of one or two color of paper. Take three, five or seven items and arrange them on a separate sheet of paper in a way you think is pleasing. Make them fill the space on your paper. Let them overlap. Leave the lighting and background until later. When you have created a design, turn it upside down. Does it still look good? Hold it in front of a mirror. How does it look now? Learn to judge for yourself. Observe art in museums. Go to a museum with the sole purpose of looking at each work from a design viewpoint.

2 Paint the Negative Shapes

On another piece of colored construction paper, use one contrasting color oil pastel to paint only the areas where there is no cutout paper in the design you created in step 1. This time, you are defining the negative shapes, the space around the positive shapes.

These designs don't work.

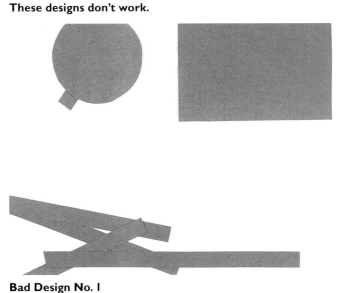

Bad Design No. 1
The objects are too near the edge and leave a big hole in the middle. Space is fine, but it needs to be thought out very carefully.

Bad Design No. 2
This is a case where nothing seems to relate well to anything else. It looks choppy and unfinished. Negative space could have been better used.

Light Your Still Life from Different Angles

The best way to understand how to light a still life is to set up a simple still life and sketch it under different lighting conditions created by a single, direct light source (a light source directly aimed at the subject). Sketching will help you learn to see and simplify the light and dark areas.

A direct light gives you dramatic shadows, strongly lit areas and highlights. It can come from any direction, one at a time. Painting in a well-lit room will overpower most of your direct lighting. Close off the overheads or drapes to see what real drama is.

MATERIALS

SURFACE
Sketch pad
(5" × 7" [13cm × 18cm] sheet)

OTHER
2 pieces of fruit and a cup (for your still life)
• Lamp • Pencil

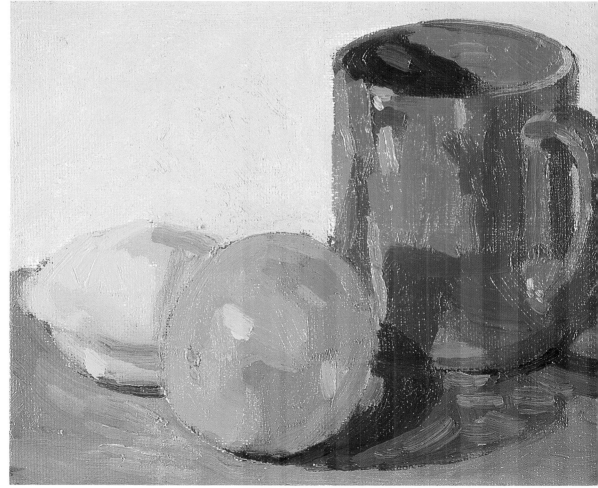

Finished Painting
I used side lighting for this painting because I wanted to show strong color. Any of the other options would work fine. The choice is up to you.

STILL LIFE FRUIT AND RED CUP
5" × 7" (13cm × 18cm)

Side Lighting

Side lighting shows clearly-defined lights and darks. Arrange two pieces of fruit and a cup. Shine a desk lamp directly on the fruit from the side. Turn off the rest of the lights in the room to see your lighting more clearly. You'll need them on again when you sketch or paint. Do an outline drawing with the shadowed area indicated clearly.

Overhead Lighting

Move your lamp directly above the setup. Overhead lighting is the kind of light that noon brings to the outdoors. Do another sketch, and pay close attention to the shadows and contrast. The shadows touch the edges and create new and interesting shapes.

Backlighting

This is the light you will see when you set an object in front of a window on a sunny day. Position the lamp behind the setup. The dark areas will cover most of the objects. Light hits just a small part of the fruit and cup. Part of the local color may show on the edges, but most of the colors do not look like their true colors. Sketch this, paying attention to the dark and light areas.

Simple Pear

Fruit has been the subject for many still life painters. I am enchanted by Cézanne's carefully placed strokes of color in his apple paintings. The opportunities for experimenting with your creativity are endless. Fruit is colorfully appealing. Its roundness and subtle tones are akin to that of a person. I like how these colored, textured little still life subjects relate to one another like a couple of people just hanging out with a cup. Set up a still life with fruit. Make sure the design works and that it pleases you.

MATERIALS

SURFACE
Canvas paper

BRUSHES
Nos. 4 and 6 rounds • Nos. 4 and 6 flats

WATER-SOLUBLE OILS
Alizarin Crimson • Cadmium Red Light • Cadmium Yellow Light • Phthalo Green • Titanium White • Ultramarine Blue • Yellow Ochre

OTHER
Pear

1 Paint the Outline
With a no. 6 round, paint a simple shape of the pear, dark side and shadow with Ultramarine Blue diluted with water.

2 Paint the Darkest Values
Squint to determine where the dark values are. On the pear, paint first the dark (Phthalo Green + Yellow Ochre + Cadmium Red Light) then the medium values (same mixture + more Yellow Ochre).

3 Paint the Areas Facing the Light
Paint the shadow of the pear (Alizarin Crimson + Ultramarine Blue + Titanium White) with a no. 4 flat. With a no. 6 flat, paint the light areas (Cadmium Yellow Light + Phthalo Green) and the background (Yellow Ochre + Titanium White). Then paint the stem (Ultramarine Blue + Yellow Ochre).

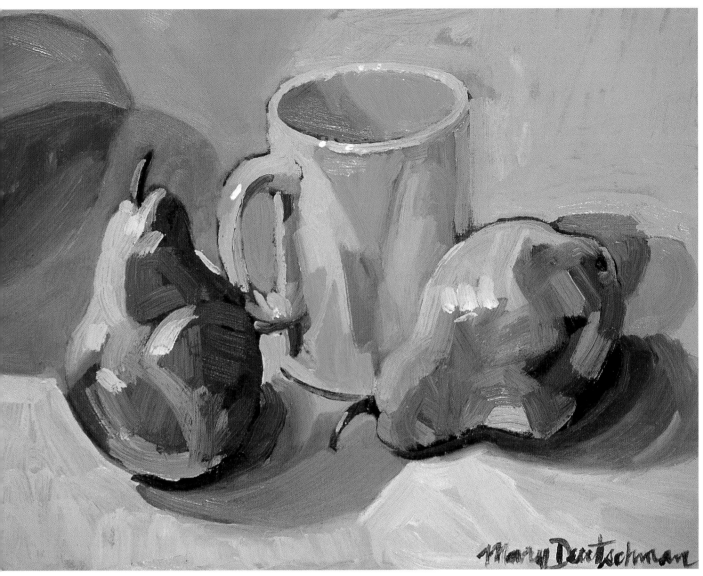

4 Final Painting

Now that you have learned to paint a pear, set it up with two other objects. I chose another pear and a cup. Using odd numbers, for design purposes, often results in a more interesting composition. The colors are compatible. I placed the second pear close to the cup so it would reflect in it. Laying it on its side gave it variety and direction.

TWO PEARS WITH A YELLOW CUP
9" × 12" (23cm × 30cm)

QUICK TIP

PAINT QUICKLY
Don't spend a lot of time painting the details. Paint quickly. Let the direction of your strokes describe the shape of the fruit.

Tulip

You can approach flowers in many ways. When you paint them as they grow outdoors, they become part of a landscape painting. Those flowers are usually painted without a lot of detail. Paint flowers in a vase with the same approach. Use minium details, and make the painting about shapes and color. When you paint a single blossom, you may want to use detail to make the flower look like a specific type.

MATERIALS

SURFACE
Canvas paper

BRUSHES
Nos. 4 and 6 flats • No. 4 filbert •
Nos. 2, 4 and 6 rounds

WATER-SOLUBLE OILS
Alizarin Crimson • Cadmium Red Light •
Cadmium Yellow Medium • Phthalo Green
Titanium White • Ultramarine Blue •
Yellow Ochre

OTHER
Tulip

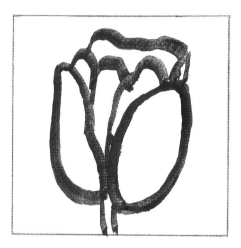

1 Paint the Outline
With a no. 4 round and Ultramarine Blue, paint the outline and shapes of the petals.

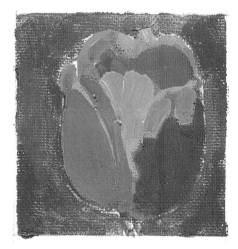

2 Paint Contrasting Reds
Paint the petal in shadow (Ultramarine Blue + Titanium White + Alizarin Crimson). Then paint the petal that faces the light (Cadmium Red Light + Cadmium Yellow Medium). Paint the background (Phthalo Green + Yellow Ochre) using a no. 4 filbert. When this step is completed, you could stop because you have enough detail for a flower in a bouquet.

3 Add Detail
Add Titanium White to the Cadmium Red Light and Cadmium Yellow Medium mixture for the lighter petals. Add more Cadmium Yellow Medium to the red and white mixture. Paint the light edge of the shadowed petal with your no. 2 round. Add more Phthalo Green to the green and ochre mixture to darken the bottom of the background. Paint the stem dark green (Phthalo Green + Yellow Ochre) on the shadowed side and less Phthalo Green mixed with Yellow Ochre for the light side.

SPRING BOUQUET
WITH TULIPS
12" × 9"
(30cm × 23cm)

4 Final Painting

The bouquet of tulips and narcissus came from my garden. I painted them their true colors, purple, pink and white. Since proportion is important in flower presentation, I selected a medium-sized vase. The cardboard that I placed close behind the flowers allowed the shadow cast from the lamp to show clearly. When you are painting a bouquet, focus on a few flowers in the foreground and suggest the rest with minimal strokes.

Reflective Objects

Start with a few pieces of fruit, then find something reflective. A stainless steel mixing bowl will do. Place an orange on a green napkin, next to a bowl, so you can see its reflection in the bowl. Take time to study these items. Painting a reflective surface is no mystery. Like everything else we paint, we will represent what we observe with strokes of color.

MATERIALS

SURFACE
Canvas paper
3" × 3"
(8cm × 8cm)

BRUSHES
No. 4 flat • No. 6 round

WATER-SOLUBLE OILS
Cadmium Orange • Cadmium Yellow Light • Phthalo Green • Titanium White • Ultramarine Blue • Yellow Ochre

OTHER
4B or 6B pencil • Fruit • Napkin • Reflective bowl

1 Outline the Shapes
Draw a 3-inch (8cm) square with a pencil. You are going to paint only a small segment of the orange and the reflection of it in the bowl. With a no. 4 flat and Ultramarine Blue diluted with water, outline the orange, bowl and the reflection of the orange with its shadow.

2 Paint the Oranges
Mix up two colors of orange: 1) Cadmium Orange + a slight amount of Ultramarine Blue (this makes your orange duller) 2) Cadmium Orange + more Ultramarine Blue (to make it darker). With a no. 6 round, paint the orange piece of fruit the duller orange color. Clean your brush with a paper towel and paint the reflection the darker orange color.

3 Paint the Background
Paint the area behind the orange reflection (Phthalo Green + Yellow Ochre), using a no. 4 flat. Add more Yellow Ochre to the mix and paint the rest of the reflection. Paint the colored napkin (Titanium White + Cadmium Yellow Light + Phthalo Green).

Notice how the orange appears smaller, darker, and duller in the reflection.

The inside of the bowl is made from the reflections of the ceiling lights.

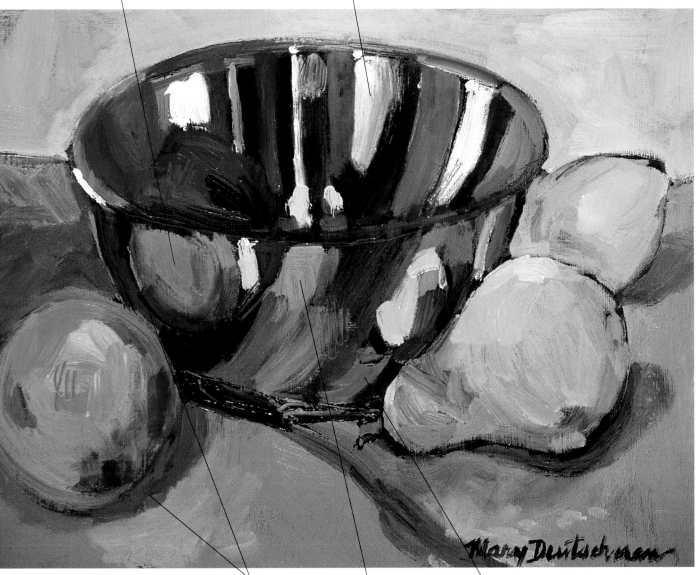

4 Final Painting

REFLECTIONS IN A METAL BOWL
9" × 12" (23cm × 30cm)

There is a darker green shadow beneath both the orange and its reflection.

The color of the napkin reflects a green color into the bowl.

The objects surrounding the bowl influence what colors the reflection will be.

ISOLATE YOUR COLORS
To help identify the subtle colors, don't forget to use your spot screen (page 34).

Transparent Bottle

Painting a glass bottle teaches you to paint transparent objects. The color you see in a bottle comes from two sources: 1) You see color reflected from objects near the bottle, like an orange or cup. 2) You see color through the glass, like the label on the other side of the bottle or the color of a wall behind it. Shine light directly on the bottle to make the colors easier to see. Transparency is not a mystery. Decide what color you see, mix it up and paint it.

MATERIALS

SURFACE
Canvas paper
8½" × 3"
(28cm × 8cm)

BRUSHES
1-inch (25mm) flat • Nos. 4, 6 flats •
No. 6 round

WATER-SOLUBLE OILS
Cadmium Red Light • Cadmium Red
Medium • Cadmium Yellow Medium •
Phthalo Green • Titanium White •
Ultramarine Blue • Yellow Ochre

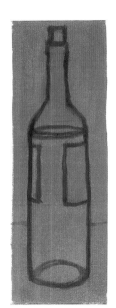

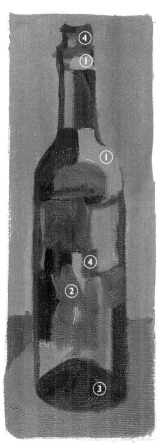

1 Paint the Outline
With a 1-inch (25mm) flat, paint the background with a light, thin coat of Cadmium Red Light. Let it dry. I use acrylic for this step because it dries faster. Paint the outline with a no. 6 round and Ultramarine Blue.

1 Phthalo Green +
 Cadmium Yellow Medium

2 Phthalo Green + Yellow Ochre

3 Phthalo Green +
 Ultramarine Blue

4 Phthalo Green +
 Cadmium Red Light

2 Paint the Dark and Medium Greens
Mix four different hues of green using Phthalo Green mixed with: Cadmium Yellow Medium, Yellow Ochre, Ultramarine Blue, and Cadmium Red Light. With a no. 6 flat, paint the darkest green value for the bottom of the bottle and strips along the sides. Use the medium green on the top of the liquid in the bottle and three or four other places. Try to keep the strokes flat.

3 Paint the Light Values
Paint the light values with light green, (Phthalo Green + Cadmium Yellow Medium + a little Cadmium Red Light) using a no. 6 flat. Using a no. 4 flat, paint the details with Cadmium Red Light and Cadmium Yellow Medium. With your no. 6 flat, paint the background (Ultramarine Blue + Titanium White) and the rectangle at the top (Ultramarine Blue + Cadmium Red Medium).

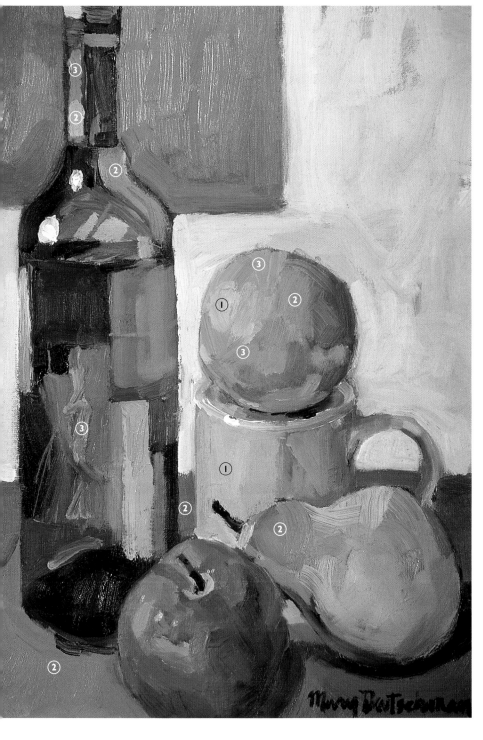

1 Cadmium Yellow
Medium

2 Cadmium Yellow
Medium + Phthalo
Green + Cadmium
Red Light

3 Cadmium Red Light

4 Final Painting

Add a yellow cup and fruit. These items are opaque. The cup and the orange affect the color in the bottle and the bottle bounces color back to them. This cup is turned over to create interest in the center of the picture. The rectangle in the background was a painting. I used it as a basic design shape and kept the color simple so the focus would remain on the other objects.

BOTTLE WITH FRUIT AND CUP
12" × 9" (30cm × 23cm)
Collection of Ellen and Tom Riehm

Pulling It All Together

Let's pull together the techniques you've practiced to make a complete still life. Because you are working with more than a single item, keep in mind to make it a painting, not something that looks like you have copied a photograph. It can be as detailed as you want, but it should still look like a painting. Let your personality shine through.

MATERIALS

SURFACE
Canvas 18" × 18" (46cm × 46cm)

BRUSHES
1-inch (25mm) flat • Nos. 4, 6 and 8 flats • No. 6 round

WATER-SOLUBLE OILS
Cadmium Orange • Cadmium Red Light • Cadmium Yellow Medium • Phthalo Green • Titanium White • Ultramarine Blue • Yellow Ochre

OTHER
Camera • Lamp • Pencil • Sketch pad or index card

1 Set Up a Pleasing Still Life
Light your subject in a dramatic way so you will see both the lights and darks clearly. Take a photo to help later when the flowers are wilted. You can use a digital camera to look at your design right away in a different size.

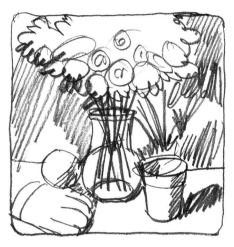

2 Do a Sketch
Sketch quickly to see your composition. If you are not satisfied with what you did, do another.

3 Paint Your Basecoat
Underpaint the canvas with one coat of a color that you like. I used purple because it is the opposite of yellow. The colors of subject matter are mostly oranges and yellows. When the basecoat dries, do an outline of the objects with a no. 6 round and Ultramarine Blue. Fill in the background with Yellow Ochre on a 1-inch (25mm) flat.

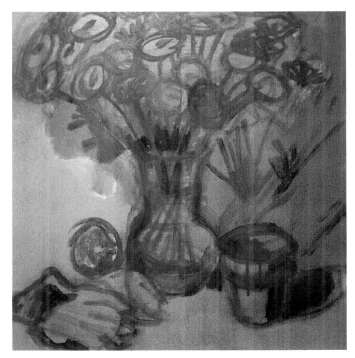

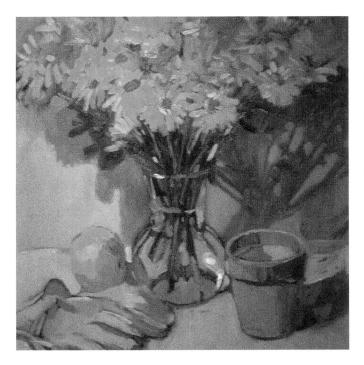

4 Paint the Darks and Mediums

Mix three values of Phthalo Green and Yellow Ochre for the stems. Keep most of the values dark. Paint the pot (Ultramarine Blue + Cadmium Red Light + Cadmium Yellow Medium + Titanium White). Make three versions of that color mixture. The shadowed areas should have more blue and red but should look like terra-cotta. Mix three proportions of Cadmium Orange + Ultramarine Blue + Cadmium Yellow Medium for the petals and orange. Paint the lightest values and details last with a no. 4 flat.

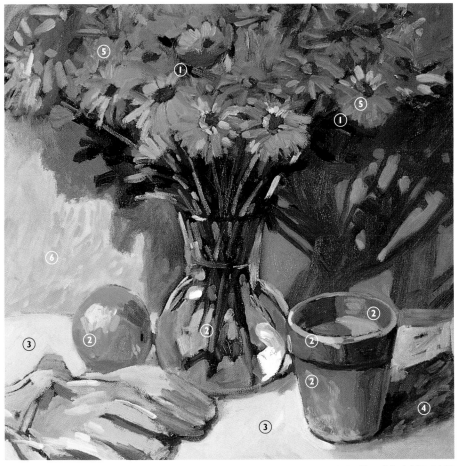

1 Add Purple behind the blossoms

2 Add strokes of Alizarin Crimson + Titanium White

3 Add Cadmium Yellow Medium

4 Add strokes of Cadmium Red Light + Cadmium Orange + Ultramarine Blue

5 Add Cadmium Red Light

6 Add strokes of Pink + Yellow Ochre

5 Add the Final Details

STILL LIFE OF A GARDENER
18" × 18" (46cm × 46cm)

Landscapes

The outdoors is big. It's much bigger than your canvas— way bigger. How does it all fit? It doesn't. Decide what part of the scene you want to paint. Use a tool like a spot screen, a viewfinder or even your hands and block everything else from your view to grasp the idea. Gradually you will be able to see the limits of your subject without a tool.

Before you completely dismiss the idea of painting an outdoor scene, try some easy exercises. I understand that painting the great outdoors can be very intimidating. Hang on. You'll get through it.

These are the things to keep in mind throughout this chapter:

1. Keep your paints clean by wiping your brush and palette knife when mixing colors. This produces clean color.
2. Try to mix no more than three colors to get the color you want. More will result in muddy color.
3. Keep color as simple as possible.
4. Paint from the general to specific.

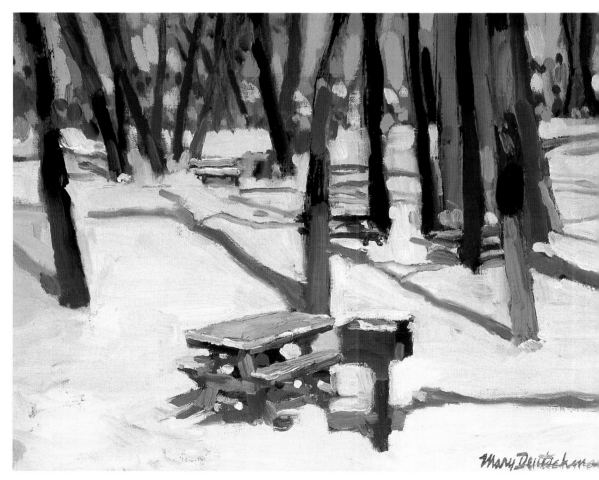

PICNIC TABLE
AND TREES
IN THE SNOW
9" × 12"
(23cm × 30cm)
Collection of Patricia
Heaton and David Hunt

Mary Deutschman

Simple Landscape

Painting on a small canvas is a wonderful way to describe a scene. It allows you to use one brush filled with paint to reach from one side to the other. It makes you simplify.

MATERIALS

SURFACE
Canvas board 5" × 7"
(13cm × 18cm)

BRUSHES
No. 4 filbert • No. 8 flat • No. 6 round

WATER-SOLUBLE OILS
Cadmium Orange • Cadmium Yellow Medium
• Phthalo Green • Titanium White •
Ultramarine Blue • Yellow Ochre

1 Take a Photo
Look for an interesting subject with a good composition to use later as a reference.

2 Paint the General Shapes
With a no. 6 round and diluted Ultramarine Blue paint, draw an outline of some simple shapes. Draw quick lines as reminders for the direction of the flowers blown by the wind. If a strong wind came up or the rain started, the photo references and the beginning of your painting, will help you create a fine painting in your studio.

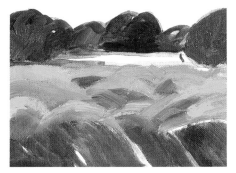

3 Paint the Trees and Foreground
Paint the background trees (Phthalo Green + a little Yellow Ochre) using a no. 8 flat. Add a little Cadmium Yellow Medium to this mixture and paint the area of the flowers. Rinse and wipe your brush. Load it with Cadmium Yellow Medium and lightly pull from left to right.

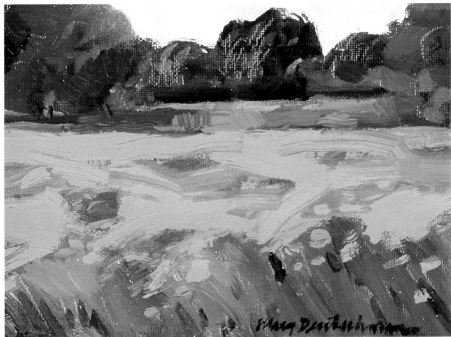

4 Add the Final Details
Add Cadmium Orange between the trees and strokes of it in the foreground for the flowers with the no. 4 filbert. Paint the sky (Ultramarine Blue + Titanium White) and the darks under the tree (Ultramarine Blue + Phthalo Green). Suggest foreground flowers bending with the wind with strokes of Cadmium Orange + Cadmium Yellow Medium to represent petals.

MEADOW OF
FLOWERS
5" × 7" (13cm × 18cm)

DEMONSTRATION
Clouds

In my childhood fancies, clouds were enormous, splendid pillows that you could bounce on. Reality set in when I flew through them in a plane. Someone explained that they are a collection of tiny particles of ice and water suspended in the atmosphere. Fascinating, but quite different from my imagination.

When I was learning to paint, I admired the clouds that were beautifully painted by a local artist. They were thick, puffy clouds suspended over hilly farmlands. I wanted to paint all clouds that way.

Clouds have many different characteristics. Painting only one kind of cloud fails to recognize nature's glorious repertoire. Clouds tell a story of light and atmosphere. They interact with the sun and the light in the sky. They cast ominous shadows over the land. Collections of them can look tall and puffy and warn of threatening storms. Clouds can be wispy and fragile against a powdery blue sky. They also can be emblazoned by a fiery, setting sun.

MATERIALS

SURFACE
8" × 10"
(20cm × 25cm)
canvas board

BRUSHES
Nos. 4 and 6 rounds

WATER-SOLUBLE OILS
Alizarin Crimson • Cadmium Red Light • Cerulean Blue • Titanium White • Ultramarine Blue • Yellow Ochre

OTHER
4B or 6B pencil • Sketchbook

1 Outline the Cloud Shapes
After sketching cloud formations in your sketchbook, use them for painting reference. Begin your painting with an outline of the clouds painted in Ultramarine Blue thinned with water using a no. 4 round.

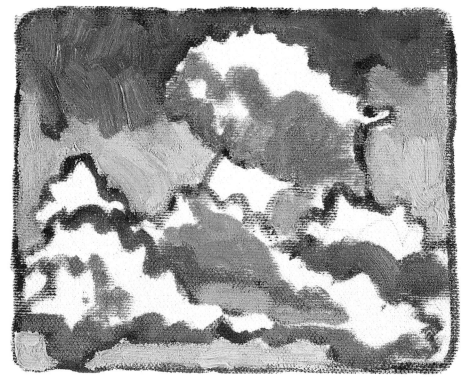

2 Paint the Sky
Describe the clouds and sky as simply as you can. Paint the top of the sky first (Ultramarine Blue + Titanium White) then paint the rest (Cerulean Blue + Titanium White). Paint the purple shadows (Ultramarine Blue + Alizarin Crimson + Titanium White), then paint the other shadows (Yellow Ochre + purple shadow mixture + Titanium White).

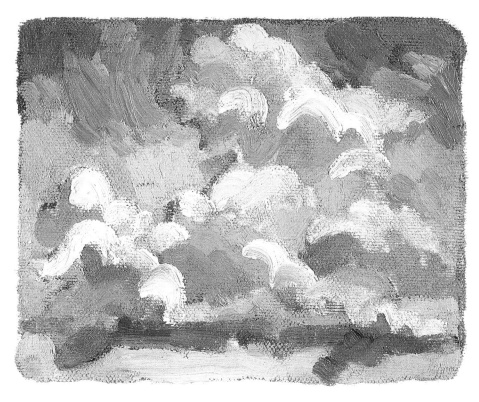

3 Paint the Lights

Add the lightest part last. This can be a very light Yellow Ochre mixed with white and Alizarin Crimson. These will be the parts that face the sun.

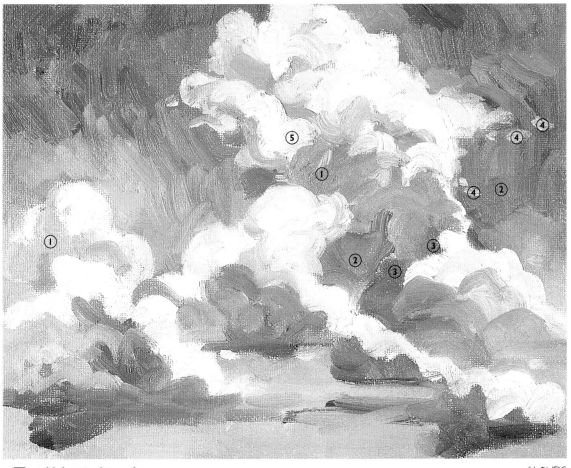

1 Lighten shadows with Cadmium Red Light + Titanium White + Ultramarine Blue.

2 Add more strokes of Ultramarine Blue to describe air movement.

3 Add more Cadmium Red Light + Titanium White.

4 To show movement, use wispy strokes of Cerulean Blue + Titanium White.

5 Add a few more lights with Yellow Ochre and Titanium White.

4 Add the Final Details

CLOUDS
8" × 10" (20cm × 25cm)

Make Your Trees Energetic

Having done many paintings in California, I am quite familiar with the lush, hilly area south of San Francisco. This was painted as a demonstration for an artists' group. The reference was a photograph I snapped while my husband drove through the winding hills while I intermittently shouted: "Slow down!" The energy of the moment stayed with me and I was able to paint it quickly.

Don't spend too much time with detail in painting trees. Keep a few things in mind. Direction and proportion are key factors. Tree trunks do not all grow vertically. Most of them grow at some kind of angle.

MATERIALS

SURFACE
Canvas paper 3½" × 4"
(9cm × 10cm)

BRUSHES
No. 4 filbert • Nos. 4 and 6 flats •
No. 6 round

WATER-SOLUBLE OILS
Alizarin Crimson • Cadmium Orange •
Cadmium Red Light • Cadmium Yellow
Medium • Phthalo Green • Titanium
White • Ultramarine Blue • Yellow Ochre

OTHER
4B or 6B pencil • Large index card

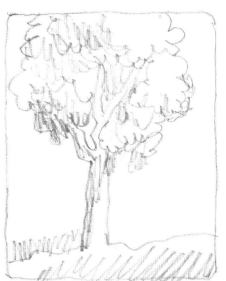

1 Sketch a Tree
Make several quick sketches of trees on your index card. Use the side of a soft pencil. Look for shape and proportion. Think about areas of light and dark. Each tree has a personality, its own way of growing. Notice that the branches are deeply embedded into the trunk.

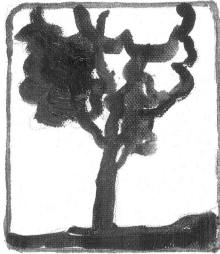

2 Paint an Outline
With a no. 6 round and Ultramarine Blue diluted with a little water, begin to paint a tree outline. Paint the trunk and a few major branches. Outline the foliage and the ground. Keep in mind that the tree is a living thing. Give it energy. Most trunks do not grow entirely vertically. Let it lean.

3 Paint the Foliage and Sky
Paint the trunk and branches (Ultramarine Blue + Alizarin Crimson + Titanium White) with a no. 6 flat. Paint the sky (Ultramarine Blue + Titanium White). Add a mass of dark color for the foliage (Phthalo Green + a slight amount of Cadmium Orange). Represent the leaves with a medium value (Phthalo Green + Cadmium Yellow Medium).

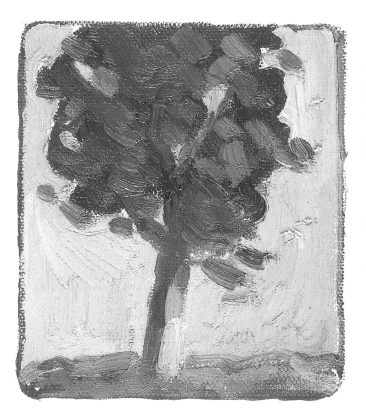

4 Add the Light Areas

Determine the direction of the light. Add small strokes of light with the no. 4 filbert (Cadmium Red Light + Titanium White) followed by Yellow Ochre + Titanium White), using your no. 4 flat. Add light greens to the foliage where the light hits the leaves. Keep the color in masses.

QUICK TIP

FIND NEGATIVE SPACE
If the trees are bare, look for negative shapes in the spaces between the branches. Paint them the color of the sky.

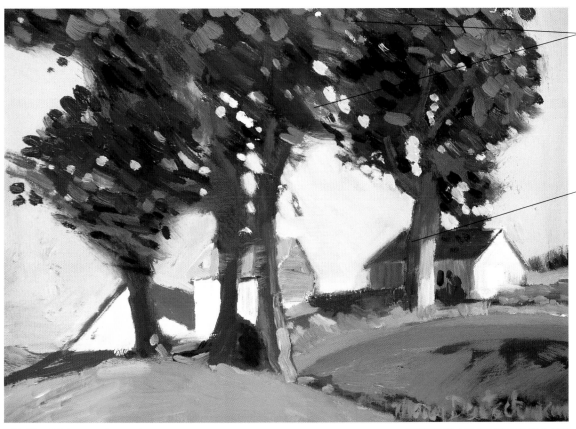

I added strokes of Cadmium Red Light to balance the Alizarin Crimson.

When I added the house, I needed to create more contrast so the trunk would separate from the roof. I used Cadmium Red Light + Ultramarine Blue + Titanium White.

TREES IN CALIFORNIA FARMLAND
9" × 12" (23cm × 30cm)

5 Add the Final Details

Now that you have learned to paint one kind of tree, incorporate it into a painting with houses and other trees.

Capture Water With Color

Nature has blessed us with vast amounts of reflective water, particularly on a sunny day. Painting water is similar to painting a bottle in that they both have transparent and reflective characteristics. When painting water, paint what you see, and it will look realistic. If it has movement, make your strokes move. If the mood is quiet, make your strokes flat. The direction of the strokes will denote the action of the water. Analyze and identify the colors, using your spot screen (page 34) to block out the other colors. The image in the water will be perhaps more blue or gray, depending on the color of the sky and the color of the water. It is changed further by the wind creating motion in the water, as well as atmospheric conditions such as fog, rain or snow.

In this scene, reflections on a perfect October afternoon lit up the underside of the aqueduct. The vivid orange of the foliage was a remarkable complement for the surrounding green park.

MATERIALS

SURFACE
Canvas paper 5" × 5"
(13cm × 13cm)

BRUSHES
Nos. 4 and 6 flats • No. 6 round

WATER-SOLUBLE OILS
Alizarin Crimson • Cerulean Blue • Cadmium Red Light • Cadmium Yellow Light • Cadmium Yellow Medium • Phthalo Green • Titanium White • Ultramarine Blue • Yellow Ochre

OTHER
6B pencil • Camera

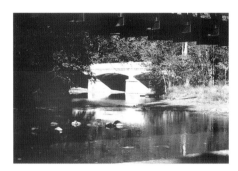

1 Take a Picture
Look for both reflections and contrasting colors in the water. Some kind of structure such as a bridge makes reflections easy to see and paint.

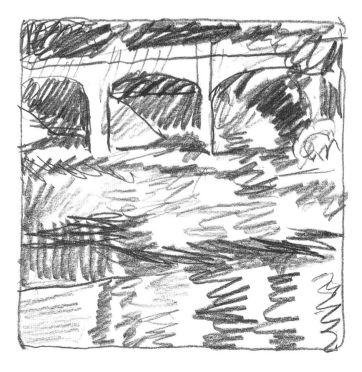

2 Create a Value Sketch
Using a 6B pencil, try to capture the values. Make your darks strong because they form your structure.

3 Paint the Outlines

With a no. 4 flat and Ultramarine Blue diluted with water, paint the outline shapes and darkest areas.

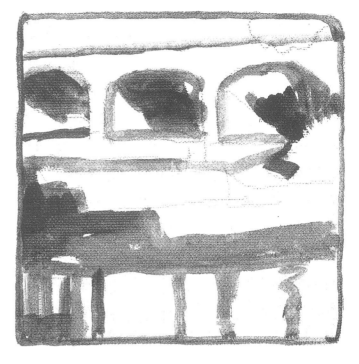

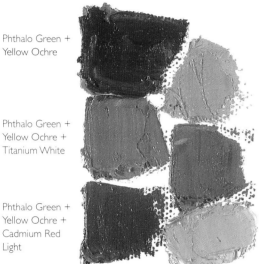

Phthalo Green + Yellow Ochre

Phthalo Green + Cadmium Yellow Light

Phthalo Green + Yellow Ochre + Titanium White

Phthalo Green + Cadmium Yellow Medium

Phthalo Green + Yellow Ochre + Cadmium Red Light

Phthalo Green + Titanium White

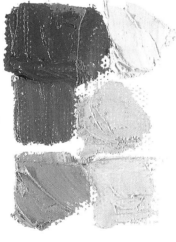

Ultramarine Blue + Alizarin Crimson + Titanium White

Ultramarine Blue + lots of Titanium White

Ultramarine Blue + Titanium White

Cerulean Blue + Titanium White

Ultramarine Blue + Alizarin Crimson + Titanium White

Ultramarine Blue + Alizarin Crimson + lots of Titanium White

4 Mix Your Blues and Greens

This chart will help you mix a variety of blues and greens. They range from very dark to very light in value. Use all of them in this demonstration.

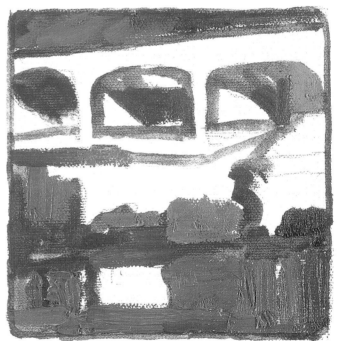

5 Begin With the Darks

Use a variety of dark greens and blues. With a no. 6 flat, begin to block in the dark greens in the water and the trees above the bridge. Define some of the shapes on the underside of the bridge with dark blues.

6 Use Your Medium and Light Greens and Blues

You now have a structure for the bridge and water. With nos. 4 and 6 flats, apply blocks of medium and light values of blue and green. Contrast is important. On a sunny day, light values look lighter and dark values look darker. This should be apparent in your painting.

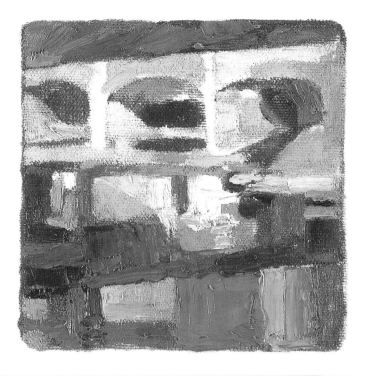

Make Reflections With a Painting Knife
Showing motion in the water reflections can be done easily with a painting knife. Put enough paint on the knife and slowly drag across the solid block of color. Don't make all the strokes horizontal. You want the water to have some movement.

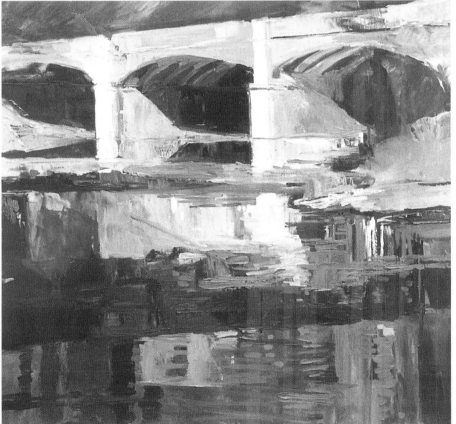

7 Add Details

With a no. 4 flat, add Cadmium Red Light to the trees, the reflections on the underside of the bridge, and the water. Add Cadmium Yellow Light to the bridge and trees above.

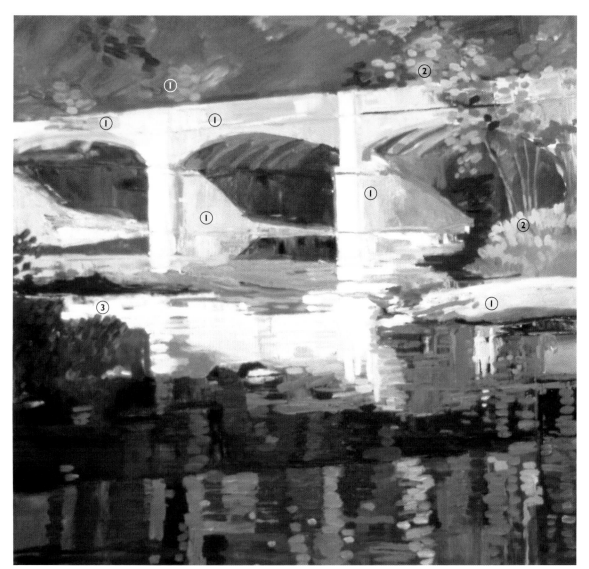

1 I added Titanium White to the underlying color.

2 I detailed the colored leaves and flowers.

3 I extended the water and added Titanium White.

8 Final Details

I believe that a demonstration for a large painting could take an entire chapter. This is a big painting with many colors and many strokes that took many days to complete. It was one of ten finalists in *Art Calendar* magazine's National Contest and represented them at the L.A. Expo.

I am attempting to show you the method and colors that I used. If the colors seem dissimilar in any way, it could be that they are. I will continue to stress that you eventually follow your own color sense.

Because painting with water-soluble oils allows you to build the color and change it as you progress, it might make you stop and wonder how a green bridge became a very pale green. Changes like that happen because you put down then observe then change a color or shape to make the final product beautiful.

REFLECTIONS OF A BRIDGE IN AUTUMN
40" × 40" (102cm × 102cm)
Courtesy of The Cleveland Clinic at Lakewood Hospital

Paint a Barn With Lively Colors

It was a nearly perfect summer sunset at a farmland in Ohio. The silo cast an impressive shadow on the barn. The remaining light in the sky gave warmth to everything in sight. The grasses in the pastures were blowing gently. I wanted to capture all of that in my painting, but I wanted more intense color.

MATERIALS

SURFACE
Canvas paper 5" × 6"
(13cm × 15cm)

BRUSHES
1-inch (25mm) flat • Nos. 2, 4, 6, 10 flats

WATER-SOLUBLE OILS
Alizarin Crimson • Cadmium Orange • Cadmium Red Light • Cadmium Yellow Medium • Phthalo Green • Titanium White • Ultramarine Blue • Yellow Ochre

OTHER
6B pencil • Camera • Index cards or sketch pad • Palette knife • Paper towels • Oil pastels • Viewfinder

1 Gather Your Reference
Take your camera, soft pencils, oil pastels and index cards outdoors. Find an area that you would like to paint. Look for interesting light and shadow areas as well as an inspiring subject. Take two or three different photos of the same scene, including several close-ups to see the detail. Have prints made of your trip outdoors (4" × 6" [10cm × 15cm] or larger are easy to work from).

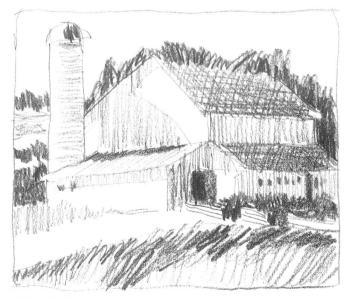

2 Set Your Pencil In Motion
Do a pencil sketch on your index card using a 6B pencil. The size of the index card will force you to keep your sketch small and manageable. Look at the scene through your viewfinder. Work from large shapes to small. Look for the value. Fill in the dark, medium and light values.

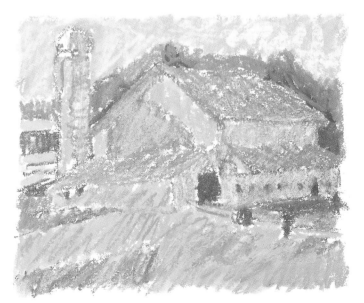

3 Sketch In Oil Pastels
Sketch two or more versions on index cards using your oil pastels. Be imaginative with your use of color. Have fun with it. These sketches will both stimulate your sense of freedom with color and trigger your memory when you are painting. Cover large areas with the side of your pastel. Blend or crosshatch for variety. Keep the images loose. Gather all the information that you can.

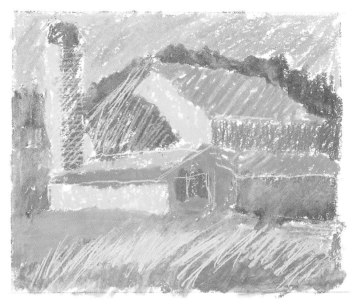

4 Do Another Version of an Oil Pastel

Make the colors completely different from the last. It will give you a good sense about how you want the paints to look. Keep working fast and try not to think too much about the exact colors. Pay attention to value. It does not matter what color it is. If it is the correct value, it will look believable.

ENSURE A GOOD DESIGN

Check your proportions during and after step 5. Step back a few feet from your painting. Hold your pencil sketch by the sides, at eye level, until the sketch and your painting seem to be the same size. Flip your sketch to a horizontal position. Look at the canvas. Return the sketch to its vertical position. Repeat until you have a sense of whether your canvas looks right. If you are not happy with your design, put a small amount of water on a rag and simply wipe your paint off the canvas. Every bit may not come off. That is OK. Start again. Two reasons: The practice will help you grow. All of the paint in your studio will not cover up a bad design.

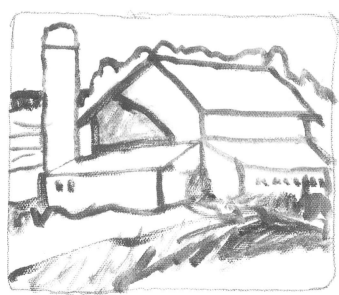

5 Establish Your Design

Dip a no. 6 flat into water, wipe off excess on the side of the container, and then dip into Ultramarine Blue. Paint the large areas of your composition directly onto canvas with the diluted paint. Keep it simple with no detail. It will take a few minutes to dry; blot to hasten the drying. While it is drying, step back a few feet to see if the composition looks good.

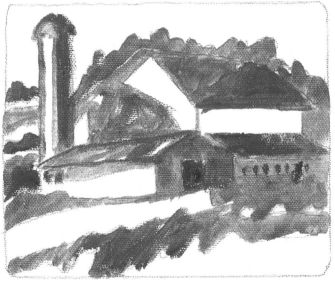

6 Paint the Darkest Values First

When you have done a drawing that pleases you, using the same Ultramarine Blue, fill in the dark values with a 1-inch (25mm) flat. Then wipe off most of the paint on the brush with a paper towel. Add a slight amount of water to dilute the paint already on the brush and paint the medium areas with that mixture. This will give you some sense of lights and darks. Let it dry.

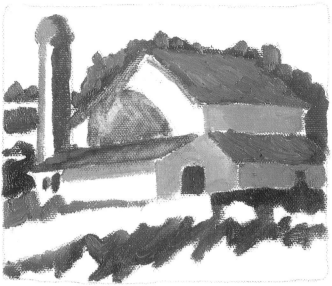

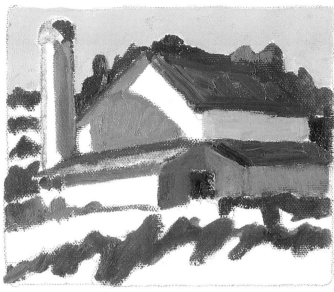

7 Paint the Dark Values

Now that you have established the design plan, add dark values. Lighten Pthalo Green slightly with a small amount of Cadmium Orange and with a no. 6 flat, paint the trees and grass in masses. Paint the side roofs on the barn and the shadow on the left part of the upper-front roof (Ultramarine Blue + Alizarin Crimson + a small amount of Titanium White). Be careful not to paint the shadows too dark. They should be about 70 percent on the value scale.

8 Paint the Medium Values

Darken Yellow Ochre with a small amount of Ultramarine Blue and with a no. 6 flat, paint the big and small shadows on the barn. Lighten Ultramarine Blue with a little Titanium White to paint the shadowed side of the barn, including the silo. Vary your blue values. Use a no. 10 flat and Yellow Ochre lightened with Titanium White to paint the sky.

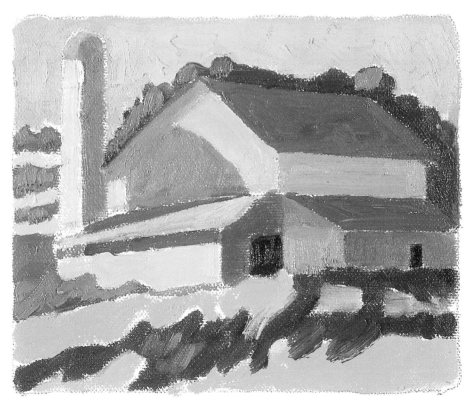

9 Paint the Lightest Values

With a no. 6 flat, paint the areas facing the sun—the left side of the silo and the front of the barn (Cadmium Yellow Medium + Titanium White). Add a touch of Cadmium Red Light to paint the grasses in the front.

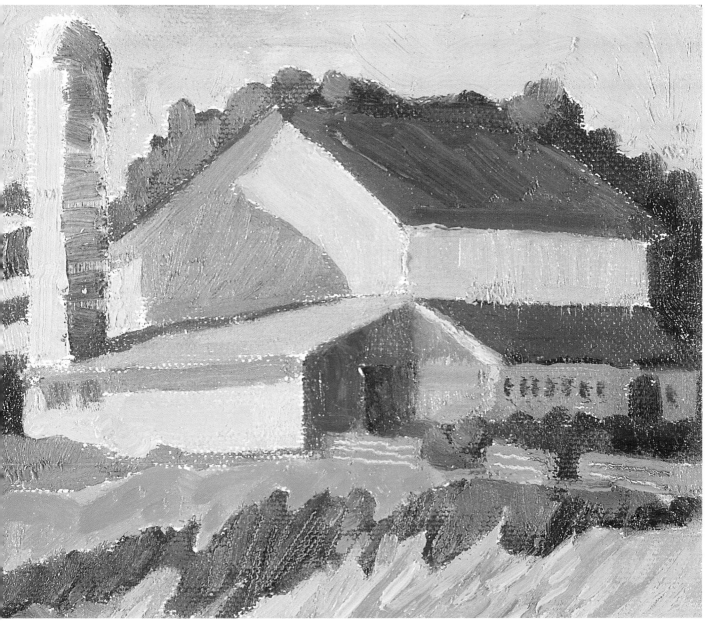

BARN WITH A PURPLE SHADOW
5" x 6" (13cm x 15cm)

10 Add the Detail

This is the time to use the smaller brushes to add the detail. With a no. 2 flat, add the fences, using Cadmium Yellow Medium and Cadmium Red Light. Make slanted strokes in the foreground to represent long grass. Add a few dots to the green area to break up the solid color and add to the spirit of movement and color. Think of them as grains of grass released by the wind. This is where you can use your imagination, making the grasses feel like they are blowing. Add windows and doors with dark blue or green. Add some areas of medium green to show where the light hits the foliage. The amount of detail that you add is up to you. Because you have progressed from general to specific throughout the painting, you have become aware that the large areas of the painting shape its destiny; the details are not as important.

Pacific Coast Cliff

Painting a view of a Pacific coast cliff is a good lesson in making different textures work together to look like part of the same picture. We have the sky, cliffs, rolling hills, water and the beach. This beach is one of my favorite places to communicate with nature. I have painted this scene many times both there, in watercolor and pastel, and in my studio with acrylic, oil and water-soluble oils. The sizes were vastly different. The largest was a $3\frac{1}{2}' \times 5\frac{1}{2}'$ (1m × 2m) commission. The key with all of them seemed to be in breaking the color down to simple shapes so first you'll need to decide what your shapes are.

MATERIALS

SURFACE
Canvas paper 5" × 5"
(13cm × 13cm)

BRUSHES
Nos. 4, 6 filberts
Nos. 6, 8 flats

WATER-SOLUBLE OILS
Alizarin Crimson • Blue-Violet • Cerulean Blue • Titanium White • Ultramarine Blue • Vermillion • Viridian • Yellow Light • Yellow Medium • Yellow Ochre

1 Take Reference Photos
Take as many pictures as you can, under as many different lighting conditions as you can. Each version may give you new inspiration.

2 Create a Value Sketch
If you are altering the shape of your original photograph, try a sketch or two to create your composition. Let it be a fun experience. Put plenty of energy into it, and you will translate that energy into your painting.

QUICK TIP

USE YOUR SKETCH ONLY AS A GUIDE
The drawing is not there as a final solution for the painting. It is a beginning. From there you must look, make decisions then build layers or scrape away in order to make your painting become what you want it to be.

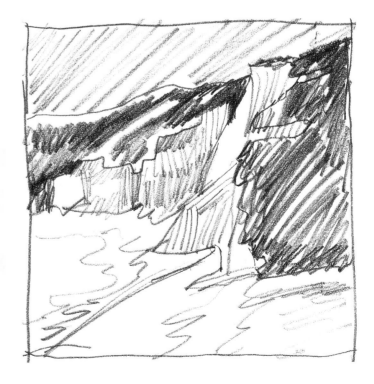

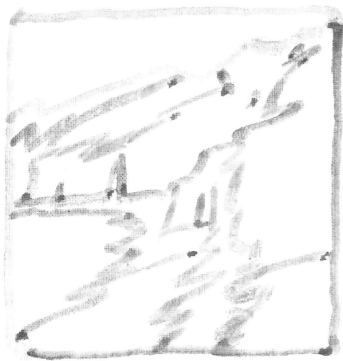

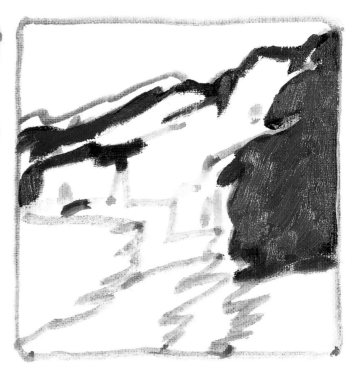

3 Outline the Scene

With a no. 6 filbert and Ultramarine Blue, do an outline sketch of the scene. Your proportions are important from the very beginning. Don't use too much paint on the brush, or it may seep into the other colors because it has not dried. Dilute the Ultramarine Blue with water (not more than thirty percent).

4 Add the Dark Colors

Use a no. 8 flat to lay in your dark greens. Viridian works, with a slight bit of Yellow Ochre. You don't want it to be too bright. This portion of the painting should move rather quickly. Right now you should still be thinking proportion, energy, and just getting paint everywhere on the canvas.

5 Paint the Mediums

Paint the portion of the sand closest to the water (Yellow Ochre + a little Ultramarine Blue + Vermillion + Titanium White), using a no. 6 flat. Remember wet sand looks darker. Paint a mass just beyond the lightest portion of water that touches the beach (Cerulean Blue + Titanium White). Ocean water is always moving. The tide ebbs and flows. Show that movement.

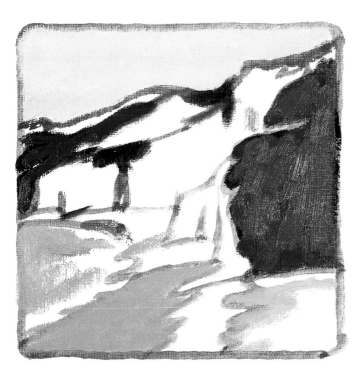

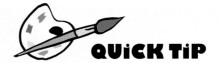

CLEAN YOUR GREEN

When using green, particularly Viridian, be careful to wash it out of your brush well. Don't let it sit around. You are likely to have some kind of stain remaining on the brush. Keep it to a minimum.

6 Paint the Light Areas

In the spirit of filling the canvas with color, paint the cliffs and part of the sand using a no. 8 flat with mixtures of Yellow Ochre + Titanium White, then add Cadmium Orange to that mixture. Mix a green (Viridian + Titanium White + Cadmium Yellow Light) and make it duller with a small bit of Vermillion.

Use These Colors to Paint the Details In Step 7

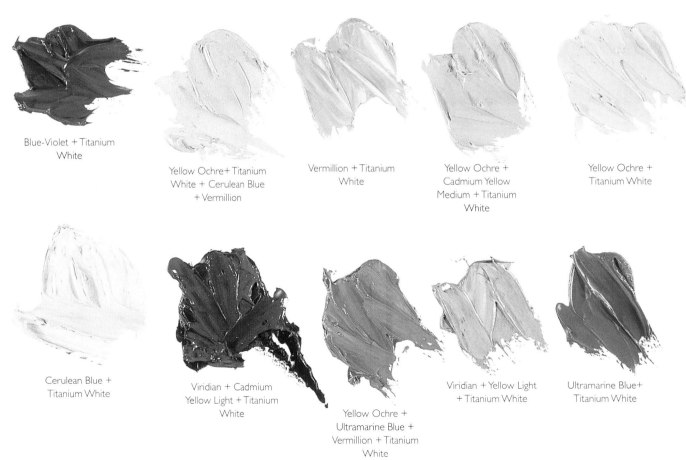

Blue-Violet + Titanium White

Yellow Ochre+ Titanium White + Cerulean Blue + Vermillion

Vermillion + Titanium White

Yellow Ochre + Cadmium Yellow Medium + Titanium White

Yellow Ochre + Titanium White

Cerulean Blue + Titanium White

Viridian + Cadmium Yellow Light + Titanium White

Yellow Ochre + Ultramarine Blue + Vermillion + Titanium White

Viridian + Yellow Light + Titanium White

Ultramarine Blue+ Titanium White

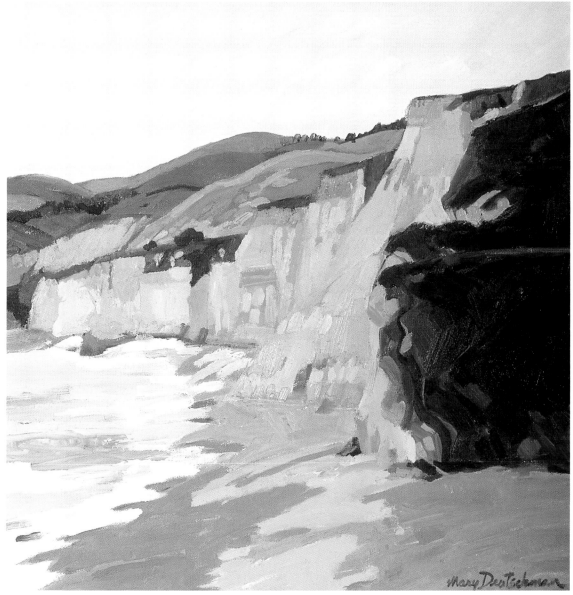

7 Paint the Detail

In order to make the cliffs look like rock, be very aware of your strokes. They should be straight and angular and strong, not wavy and soft. This painting is really a study in different textures: rocky cliffs, grass, moving coastline water, sand.

This is the part that is the most time consuming. Expect that. It will be fun, as well. Let your sense of color shine in the colors of the cliff, sand and water. Keep the colors in the distance light and subdued in contrast.

PESCADERO BEACH AND CLIFF
18" × 18" (46cm × 46cm)

QUICK TIP

LOOK AT OTHER ART FOR INSPIRATION

There are many books available on the California Artists. See how they approach this kind of scene. Everyone has a different way of working.

Look for California Artists in a search engine on the internet. You will be inspired beyond belief. Look for artists like William Wendt, Maurice Braun, Edgar Payne, and the Society of Six.

Enhance Landscapes With Extraordinary Color

Maybe you have just returned from Mexico where you saw bright color everywhere. Maybe you have just seen a museum show that featured the Fauves. Perhaps you just love color. Turn up the south of the border music and get ready to try a different approach to your use of color.

I often paint my canvas with Cadmium Red Light acrylic before I start. If you do this, allow a day for it to dry. You can do an entire painting over this basecoat, and some of the spots will show through where you didn't apply paint over it. I always start with my small color sketch to get a sense of the color. I break the painting down in the same steps, except I use very bright colors. Just try it. Use limited bright colors or use all of them together. Don't mix them. Be bold. You are sure to feel exhilarated by the process.

WORDS TO KNOW

FAUVISM (1905-1908)
Fauvism painters was the first Avant-Garde movement of the 20th century. When this unknown (Matisse, Braque, Duffy, Derain, Vlaminck) group of painters was introduced in Paris, they became known as the WILD BEASTS OF COLOR because of their vivid use of pure colors.

Find Vibrant Colors In a Market
Fruits, vegetables and awnings are wonderful inspiration. Markets are brimming with color. Take your camera there and bring home lots of food for thought as well as for the body.

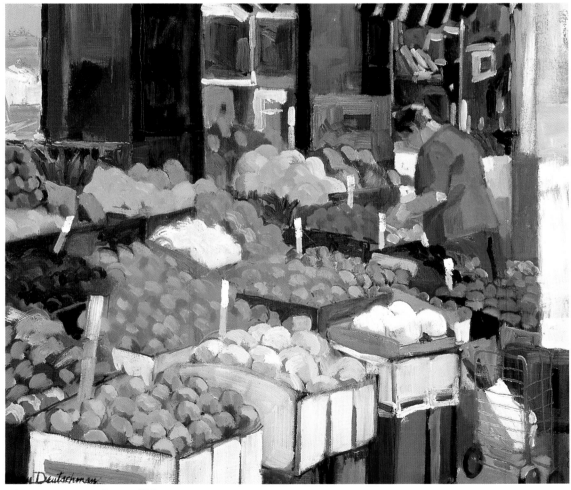

KENSINGTON MARKET SHOPPER
20" × 24" (51cm × 61cm)
Collection of Patricia Heaton

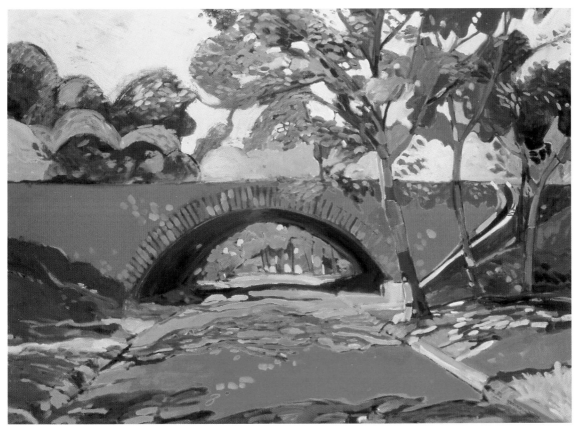

Add Color Where You Want to See It

The sky was blue, the bridge and road were gray, and the trees were all green. I wanted color. Don't be afraid to add it where you want to see it. Try it first in oil pastels or on the computer.

RED BRIDGE THROUGH
ROCKEFELLER PARK
36" × 48" (91cm × 122cm)

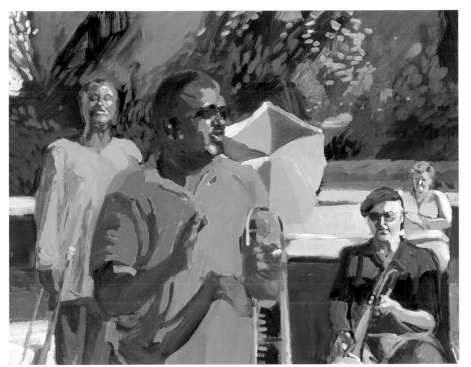

Capture a Scene's Soul With Bold Colors

When I go to New Orleans, I always spend some time in Jackson Square being entertained by the jazz musicians. They are all very accomplished musicians and play great Dixieland, but they are much more than that. They are showmen. Take a camera there and you will find music with movement. New Orleans is full of life and color and inspiration.

N'ORLEANS STREET MUSICIANS
24" × 30" (61cm × 76cm)

People

There was a time when all clothing was advertised by illustration rather than photography. I was a fashion illustrator. I drew figures every day. Making the clothes look like they were on a real figure was essential, so a model put on the dress or coat and stood there while the artist drew her. Figures should look believable. Detail is not the answer. People need to look like they are standing or sitting or lying down. If they are not drawn correctly, they will look stiff. The answer, of course, is to practice drawing people before you paint them.

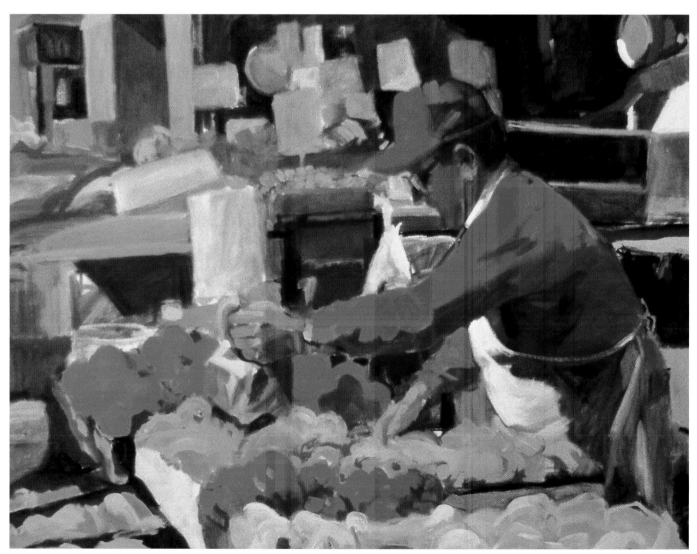

JOHN ANSELMO'S FRUIT STAND
30" × 36" (76cm × 91cm)

Three Ways to Show People in Paintings

Paintings can show people in various ways. They can be subjects of a portrait, when your goal is to paint a likeness; a small part of a landscape, showing very little detail, adding to the interest of the painting; or anonymous people, shown up close, in some kind of setting. Like nouns, these paintings are mostly about persons, places or things.

Portrait

Many are head and shoulders of a particular person showing his facial features and expression, but it can also be a full figure. The full figure portrait tells much more about the person.

Non-Specific Figure

The actions of the people in the scene are more important than who they are.

Enhance a Landscape With Figures

The main focus of this type of painting is the landscape. These people add interest to it and may be captured in a few strokes. Little detail is shown. This is the way you might render someone far away or part of a crowd.

Portrait

Close up painting of a face or an entire body that shows who the person is and sometimes what they do. They show more detail that the others. The vendor at the market (page 90) is shown going about his daily work selling fruit and vegetables. The baker in this painting is shown at his job. Both of these paintings describe the person in enough detail to be a portrait.

BAKER AT WEST POINT MARKET
12" × 9" (30cm × 23cm)
Collection of The West Point Market

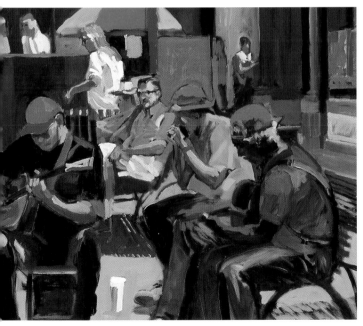

Non-Specific Figures
These people are not painted in the detail of a portrait. They are painted to look like musicians. You can see what they are doing but not who they are. Notice that their face lacks detail.

N'ORLEANS MUSICIANS, GROUP OF THREE
24" × 30" (61cm × 76cm)

Enhance a Landscape With Figures
People add interest to a landscapes. They are usually in the distance or part of a crowd. Little detail is shown. Their entire figure may be captured in a few strokes.

MONET'S GARDEN
9" × 12" (23cm × 30cm)

Create Interest In a Landscape With Figures

Using figures in a landscape is quite different than painting a portrait. Much less detail is involved. The figure is just a figure. It's not a specific person. Unspecific as the figures are, they are where the eye immediately goes. A park means so much more when there are people to capture the eye of the beholder.

The viewer's eye is immediately drawn to the action. People are walking their dog. Others are sitting on benches. The people have given energy and interest to the park. The viewer is involved.

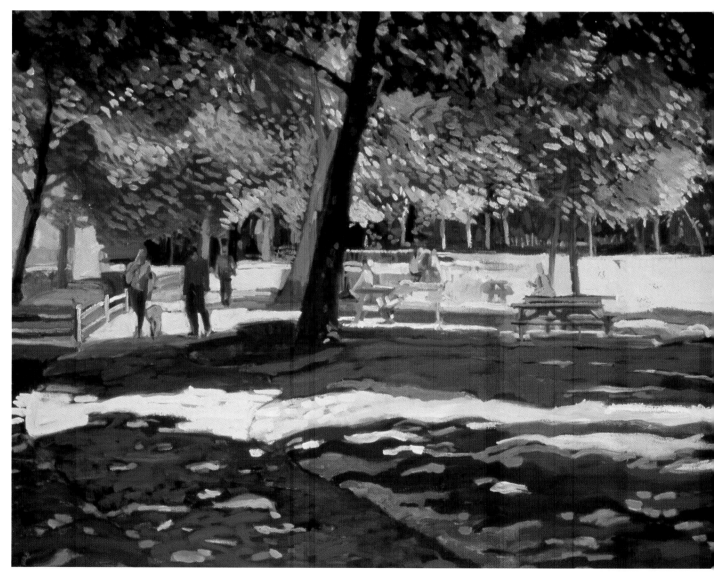

Create an Atmosphere In Your Painting With People
We all have memories of weekends at the park. Here the people walk their dogs, enjoy the sun, eat their picnic lunch. Create that atmosphere. There will be more to remember about your painting.

HUNTINGTON PARK WITH DOG WALKERS
36" × 48" (91cm × 122cm)

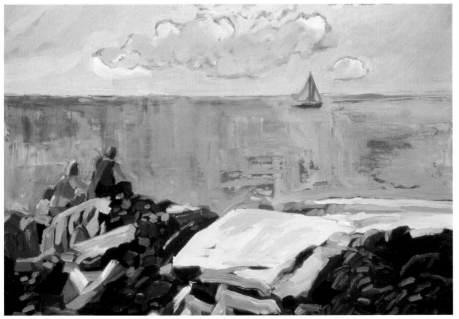

All the information is there to identify them as people, perhaps related, wearing casual clothes, sitting on the rocks with sunlight hitting them on their left side. There is no other information necessary here. The scene is more engaging because of their presence.

Use People to Enhance a Scene

Three people are grouped together enjoying an offshore breeze while a boat sails by in the distance. The large rocks provide a strong ground for the picture. The water and clouds provide the mood.

THEIR PLACE IN THE SUN
18" × 24" (46cm × 61cm)

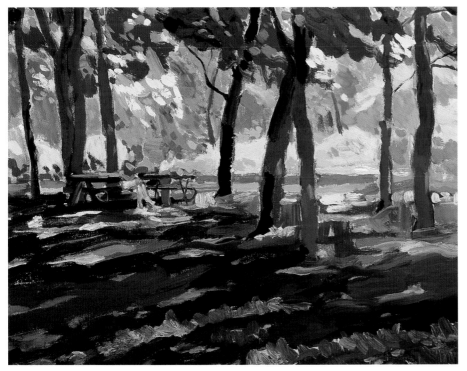

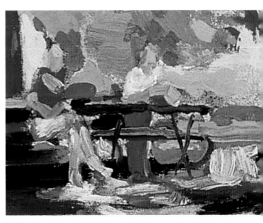

When the area with the people is separated from the picture, you realize that it took only a few strokes to represent them. You can learn a lot by enlarging and cropping into a small part of your painting. This one is almost nonrepresentational. It could be an abstract.

Depict People In Only a Few Strokes

The figures are small and are rendered very much like the rest of the picture, yet they keep the landscape from becoming just another woods. There is a suggestion that something is happening here. Keep your viewer involved in your painting.

LATE SUMMER AT EDGEWATER PARK
16" × 20" (41cm × 51cm)

Sketch People Before You Paint Them

I fell into the habit of carrying a sketch-book with me whenever I was going to be anywhere where people would gather: restaurants, jazz clubs, airports, hospital waiting rooms. What a wonderful source of reference for your paintings. In places like these, people are in very natural positions, often relaxed, holding a position long enough for you to capture the pose. You will get better each time you do a new sketch.

STUDY ANATOMY
Learn about human anatomy. There is a book called ATLAS OF HUMAN ANATOMY FOR THE ARTIST by Stephen Rogers Peck. Guidelines in there will help you learn. Figures should look believable. This will show you how the muscles and skeletal system contribute to the way a body works. Study people and observe what happens when they move.

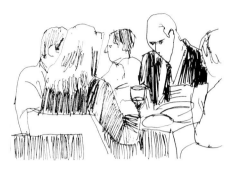

Capture the Mood
Often the subjects are unaware of your presence. Sketch fast. These people are here to eat and have fun.

Notice Subtle Details
At the airport, many passengers are deeply engrossed in whatever waiting people do: reading a paper, or a book, or staring into space. Pay attention to what their clothes do as they sit. Look at folds and shadows. Notice what happens to their hands as they clench the newspaper.

Show Body Language
People in waiting rooms of hospitals are often filled with angst and show a different kind of body language. Capture the action and do it quickly. Try to not be intrusive.

Illustrate Emotion
When people are weary, they almost become the chair they sit in. If a person is leaning on his arm, be sure you draw him so it looks that way. Your sketch will always be more alive when you do it fast.

Drawing Musicians
Joyce Breach is a New York City jazz singer. I sketched her in many poses over a few years and painted a couple of her album covers. The other people in her band always add interest to the composition.

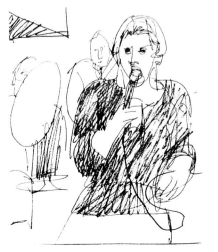

SKETCH YOURSELF
Practice sketching yourself in the mirror. Remember, you are your most patient model.

Mixing Flesh Tones

These can be made from many colors. Use the combinations you like. The varieties are endless when you take into account all races and all lighting conditions. I have mixed a few of my favorites. You may choose some from here or find new combinations. No matter how dark or light a person's skin is, you can mix the color from any combination, but you must always use the correct value if you want it to look believable.

Ultramarine Blue + Titanium White

Cadmium Red Light + Cadmium Yellow Medium

Cadmium Red Light + Ultramarine Blue

Alizarin Crimson + Ultramarine Blue + Cadmium Yellow Medium + Titanium White

Phthalo Green + Cadmium Yellow Medium + Titanium White

Cadmium Red Light + Ultramarine Blue + Cadmium Yellow Medium + Titanium White

Cadmium Red Light + Cadmium Yellow Medium + Titanium White

Yellow Ochre + Ultramarine Blue

Cadmium Red Light + Ultramarine Blue + Cadmium Yellow Medium

Alizarin Crimson + Ultramarine Blue + Cadmium Red Light + Titanium White

Yellow Ochre + Titanium White

Alizarin Crimson + Ultramarine Blue + Yellow Ochre + Titanium White

Head and Shoulders Portrait

Work from a model whenever you can. Keep in mind that most people find it hard to hold a pose. Be sure to take a photo so you can continue the painting on your own. When you feel comfortable sketching a head, you are ready to paint one.

MATERIALS

SURFACE
Canvas paper 4" × 4" (10cm × 10cm)

BRUSHES
Nos. 2, 4, 6, 8 filberts • No. 10 flat

WATER-SOLUBLE OILS
Alizarin Crimson • Cadmium Orange • Cadmium Red Light • Cadmium Yellow Medium • Phthalo Green • Raw Umber • Titanium White • Ultramarine Blue • Yellow Ochre

OTHER
Camera

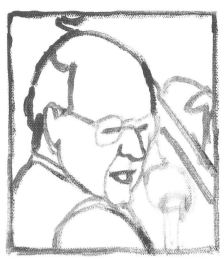

1 Create a Basic Outline
Outline the basic shapes of the head and shoulders in Ultramarine Blue diluted with water using a no. 4 filbert. Focus only on the general shapes; don't worry about the detail here.

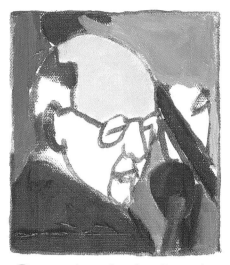

2 Paint the Dark and Medium Values
Paint the large areas of dark and medium values first with a no. 10 flat. Paint part of the gray background (Phthalo Green + Cadmium Yellow Medium), then paint the other part (Cadmium Red Light + Cadmium Yellow Medium + Titanium White). Mix up some medium-value flesh tone (Cadmium Red Light + Cadmium Yellow Medium + Titanium White + Ultramarine Blue) and begin to paint the large areas of the face with a no. 8 filbert.

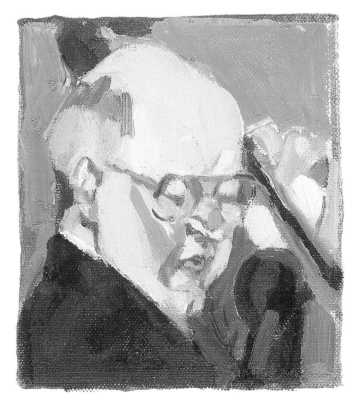

3 Enhance the Face and Background
Finish the medium flesh areas, then add some of the more colorful parts of the face like the cheeks and lips and nose. Use your no. 6 filbert. Make the areas away from the light slightly cooler (add blue) so these areas recede. Keep the colors closer to the light warm. Look hard at your model to see the color. Keep adding strokes until you feel that it is finished. Keep it simple.

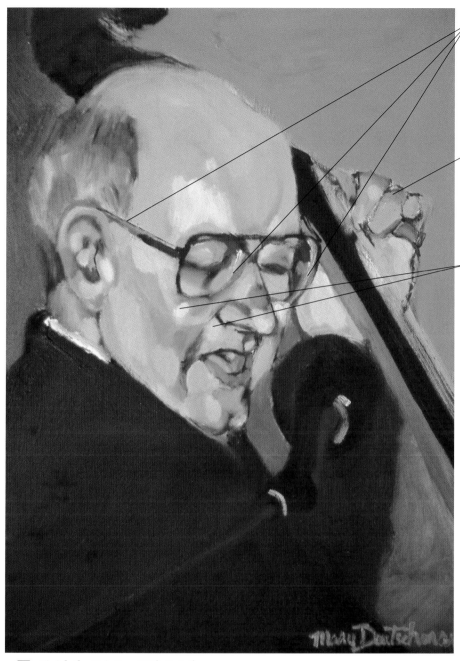

Add Phthalo Green highlights to his glasses.

Define his hands with a dark line of Ultramarine Blue.

Add Yellow Ochre and Titanium White daylight highlights.

4 **Finish the Painting With Detail**
The most important part of the picture is the face and its flesh tones. Until now, the face has been only a flat flesh tone. Now is the time to develop the character. Add highlights, on the skin where the light hits the face, using degrees of Yellow Ochre and Titanium White. Be particular about his glasses. Add some Phthalo Green for the highlights. Define his hands with a darker line of Ultramarine Blue.

DICK MEESE SINGS AND PLAYS BASS
16" × 12" (41cm × 30cm)

QUICK TIP

SET UP LIGHTING THAT LOOKS RIGHT

If you are in a jazz club, you might have to shoot your picture with light that's available. If your subject is in your studio, you can light him exactly the way you want. Use a single light to create drama. If you are outdoors, plan the right time of day or move the subject to please you.

Simple Figure in a Landscape

Have someone pose in a relaxed position either outside, where you can see areas of sunshine and areas of shade, or inside, where your light source creates lights and darks. It is the combination of light and shadow that creates depth. This scene is a beautiful park in the center of Niagara-on-the-Lake in Canada. A figure sits in a relaxed position on a sunny park bench. The sunlight and shadows everywhere seem perfect. I feel comfortable taking several shots, some up close. The subject is my husband—life is better when you bring your own model.

MATERIALS

SURFACE
Canvas paper 6" × 6" (15cm × 15cm)

BRUSHES
Nos. 2, 4, 6, 8 filberts • No. 10 flat

WATER-SOLUBLE OILS
Alizarin Crimson • Cadmium Red Light • Cadmium Yellow Medium • Orange • Phthalo Green • Raw Umber • Titanium White • Ultramarine Blue • Yellow Ochre

OTHER
Camera

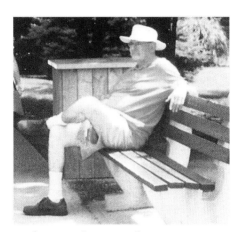

1 Compile Your Reference

Take several photos or begin with a sketch to help you with the composition. If you are photographing a stranger, use a long lens to be less intrusive.

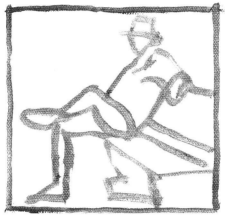

2 Paint the Outline

Dilute Ultramarine Blue paint with water just until it flows smoothly and paint with a no. 4 filbert. Indicate the basic shapes in the background. If the person is sitting, be sure to include what he's sitting on so he doesn't look like he is floating.

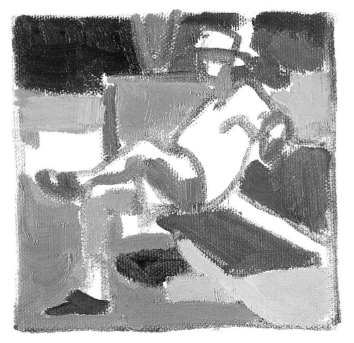

3 Add the Dark and Medium Values

We are focusing on the figure here. Block in the background colors first, with colors that suggest sunshine and shade (dark greens, light greens, purple), and then concentrate on the figure. Pick a medium flesh value to represent the skin area in shadow (Yellow Ochre + a slight amount of Ultramarine Blue + Cadmium Red Light + Titanium White). Paint his right calf (Cadmium Orange + Titanium White + a little Ultramarine Blue) using a no. 4 filbert.

QUICK TIP

SQUINT
Don't worry about the detail of the clothing. Concentrate on the shape of the body. That will dictate where the darks and lights go. Squinting will help you see a better definition of light and dark.

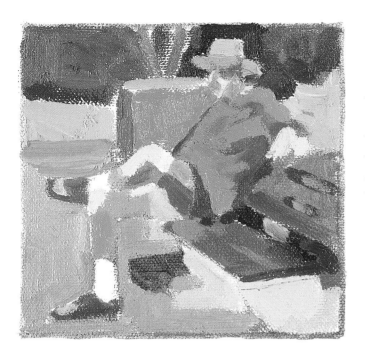

4 Paint the Light Areas

Paint the lightest part of his skin on his legs, face, hand and arm (Yellow Ochre + Titanium White) using a no. 2 filbert. Paint the light part of his shirt (Cadmium Red Light + Cadmium Yellow Medium) using a no. 6 filbert. Paint Cadmium Yellow Medium on the sunlit part of the top of his hat. Add Yellow Ochre under the brim of his hat to resemble a more shaded version of the Cadmium Yellow Medium. Paint his socks (Titanium White + a little Yellow Ochre and Ultramarine Blue). Keep facial features to a minimum. Keep in mind the importance of the correct value.

QUICK TiP

SHADOW VALUES
The brighter the sun, the darker and less detailed the shadow.

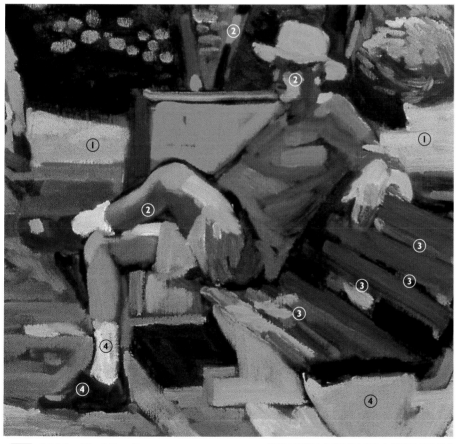

5 Add the Final Details

I The green in the background is too bright. I added a little Cadmium Red Light to the Viridian and Yellow to make it more subtle.

2 I added Cadmium Red Light in these areas.

3 I defined the bench here.

4 I changed the color in these places by adding Yellow Ochre and Ultramarine Blue.

MAN WITH A TILLY ON A PARK BENCH
30" × 40" (76cm × 102cm)
Collection of Patricia Heaton and David Hunt

Tell a Story With a Portrait

The enthusiasm that this woman displayed in showing off her fresh fish inspired me to add spots of color everywhere. They somehow made the painting more alive with both energy and color. Because the area around her is so filled with color (the lobster in the foreground and the greens in the back), it creates a festive mood for the picture. Don't be afraid to add color where gray and black and white exist in reality. The value is important. Her pose and connection to the fish are as important as the expression on her highly colored face.

MATERIALS

SURFACE
Canvas 9" × 12"
(23cm × 30cm)

BRUSHES
Nos. 2, 4 and 6 filberts • Nos. 4 and 6 rounds

WATER-SOLUBLE OILS
Alizarin Crimson • Burnt Sienna • Cadmium Orange • Cadmium Yellow Light • Titanium White • Ultramarine Blue • Yellow Ochre • Vermillion • Viridian

OTHER
4B or 6B pencil • Camera • Jar of water • Sketchpad

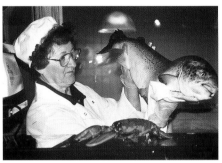

1 Take a Reference Photo
Take several photographs in rapid succession in order to capture the right moment and expression. People who are not professional models are sometimes self-conscious in front of a camera. Try to be discreet and allow them to be comfortable. You'll love the result.

2 Establish a Design With a Sketch
Do a quick pencil sketch (and an oil pastel if you wish). This is the time to concentrate on design, large masses of dark and light (value) and movement. Capture them all in swift strokes. Leave the detail for later.

3 Outline Your Subject
You are already familiar with your subject, so this step is to apply the design to the canvas. Dip your no. 6 filbert into water, then take Ultramarine Blue and begin your outline drawing on the canvas.

4 Establish Your Darks
Mix the dark and medium values on your palette: Ultramarine Blue with a very small amount of Titanium White for the dark blue. Mix Viridian + Titanium White for the aqua color. Mix Viridian + Yellow Ochre for the dark greens, and to that add a little Cadmium Yellow Light for the lighter areas. The brown hair and background can be variations of Vermillion + Ultramarine Blue.

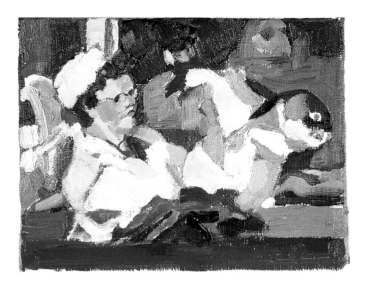

5 Add the Lights

Mix the following on your palette, being sure to wipe your palette knife before picking up a new color: Cadmium Yellow Light + Titanium White (highlights on sleeve and hat), Yellow Ochre + Titanium White (highlights on fish, sleeve and blouse), Cadmium Orange + Titanium White (highlights on skin), Ultramarine Blue + Titanium White (shadows on blouse and hat), and Cadmium Orange + Cadmium Yellow Medium + Titanium White (flesh in light) add Ultramarine Blue to the flesh tone for shadows.

Both the Lobster and the cheek are made from Vermillion + Titanium White + very small amounts of Ultramarine Blue and Cadmium Yellow Light.

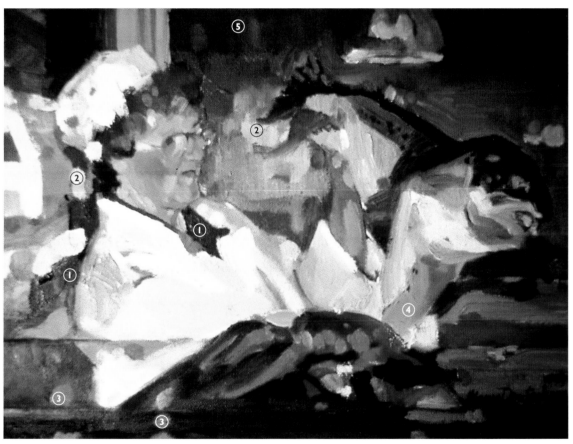

1 Darken areas with Alizarin Crimson + Ultramarine Blue.

2 For these spots of color, add Viridian to Titanium White with a no. 4 round.

3 Ultramarine Blue + Titanium White; Alizarin Crimson + Titanium White

4 Define the shadow on her hand with Ultramarine Blue + Vermillion + Titanium White + Cadmium Yellow Light.

5 Darken this area with Viridian + Ultramarine Blue.

6 Kick the Fun Up a Notch

Darken areas for more contrast and add dots of color. Guaranteed to make you smile.

LADY AT WEST POINT
MARKET SHOWING FISH
9" x 12" (23cm x 30cm)
Collection of The West Point Market

Show Action In a Portrait

Someone has known this person since he was small. He wants you to paint a portrait of him. The idea of doing a formal portrait seems out of character. Our hero is an informal, hard working kind of guy. He spends most of his time at his job. Instead of a formal head and shoulders view, why not paint him doing what he does best? Your painting will become far more personal to those who remember him.

MATERIALS

SURFACE
Canvas paper 5" × 4"
(13cm × 10cm)

BRUSHES
Nos. 4 and 6 rounds • Nos. 2, 4 and 6 filberts • No. 8 flat

WATER-SOLUBLE OILS
Alizarin Crimson • Burnt Sienna • Cerulean Blue • Orange • Titanium White • Ultramarine Blue • Yellow Light • Yellow Medium • Yellow Ochre • Vermillion • Viridian

OTHER
4B or 6B pencil • Camera • Jar of water • Sketchpad

WORDS TO KNOW

PORTRAIT A portrait is a representation of a face of a real person. It may be head, torso and head, or full length. It can be depicted as truth or beauty. The artist may paint that person in terms of his own feelings. Nearly all of my paintings of people show the subject doing something.

1 Take a Photograph
Your subject is preparing oysters in the seafood bar of a well-known restaurant. The lighting is dim. You have to depend on the flash from your camera. Take a few pictures to be sure that you get the pose you want.

2 Do a Sketch
The sketch should be mainly about the values and the design on the canvas. Decide what size canvas you will use, then do a sketch using as much of him as necessary to tell the story. Decide how it will fit on the canvas. Do it fast. Make the lines have energy.

3 Paint an Outline
With Ultramarine Blue and a no. 6 round, draw the outline of your subject. Indicate the tilt of the head and where the features will be.

 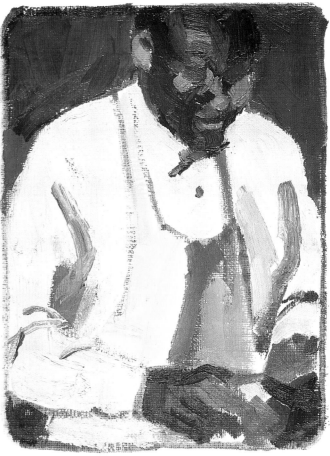

4 **Paint the Dark Values**
Mix your background (Alizarin Crimson + Ultramarine Blue + Titanium White). Allow it to remain dark by blending in only a very small amount of Titanium White. Mix the shadowed side with a little more Ultramarine Blue and more Alizarin Crimson on the lighter side.

5 **Paint the Medium Values**
Paint the shirt (a little Ultramarine Blue + Titanium White + Yellow Ochre) using a no. 8 flat . Paint the right side of the apron (Alizarin Crimson + Titanium White), (Purple + Titanium White) and (Yellow Ochre + Titanium White). Paint the left side (Yellow Ochre + Titanium White).

6 Paint the Lights and Add Detail

Build strokes of the correct value in the shirt and apron. The shirt is white, but don't paint it all white. Use the colors in the color swatches below.

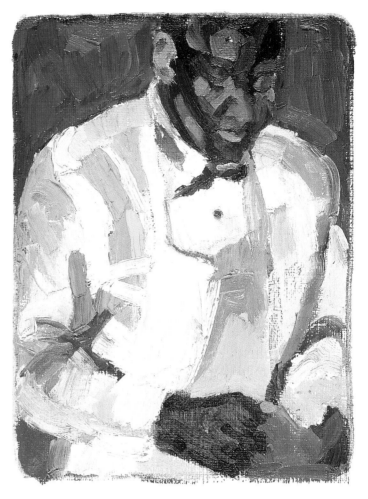

Step 6 Color Swatches

Ultramarine Blue+ Titanium White + Yellow Ochre	Yellow Ochre + Titanium White	Ultramarine Blue + Titanium White	Alizarin Crimson + Titanium White + a trace of Ultramarine Blue	Alizarin Crimson + Yellow Medium	Ultramarine Blue+ Titanium White + Alizarin Crimson + Yellow Ochre

Purple + Titanium White Burnt Sienna Purple + more Titanium White

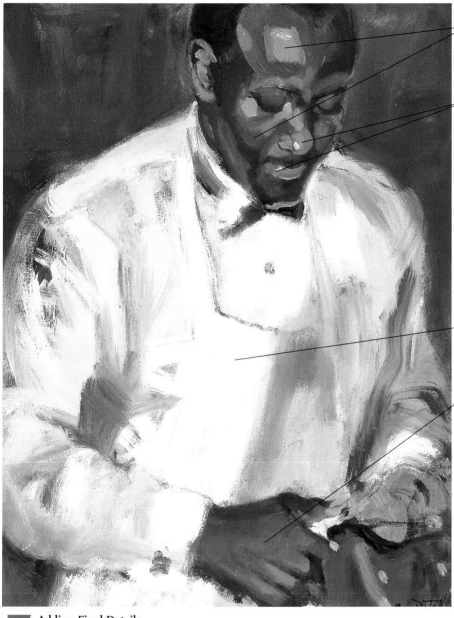

Add more color with Vermillion + Ultramarine Blue.

Add highlights (not just Titanium White but Titanium White + a hint of Burnt Sienna).

Add Yellow Ochre + Titanium White.

Define his hand with Vermillion + Ultramarine Blue.

7 Adding Final Details

This final piece was done in a much larger size than the demos. You can easily stop with step 6. The callouts are here to help you if you choose to go further.

PREPARING OYSTERS AT SAMMY'S
30" × 24" (76cm × 61cm)
Collection of Patricia Heaton and David Hunt

QUICK TIP

SKIN TONES

Mix some simple dark skin tones with Burnt Sienna + Titanium White, Raw Sienna + Titanium White, and Burnt Umber + Titanium White. Highlights on the skin will be a bluish shade made with Ultramarine Blue + Alizarin Crimson + Titanium White + Yellow Ochre. A stroke of Raw Sienna on the cheek when you have basic tones of light and dark, a stroke of Burnt Sienna and Titanium on the forehead all the time keeping in mind the most important thought: Look for value, mix up that value and put it where you think it should be. Continue to build your painting this way.

Free Your Spirit

When I lived in Pittsburgh, I studied with Tish Corbett, a wonderful lady and painter. About both life and painting, she taught me to be free to express myself. To her, I am eternally grateful. In these next activities, I will share some of the principles she taught me.

These are fun exercises to liberate you from years of conventional thinking about what everybody else thinks art is. Paint like you are four years old. And no matter how you paint, be your own person. These exercises will also help you if you feel stuck. They teach you to see things in a different way and start with a fresh approach.

MATERIALS

SURFACE
Canvas paper or index card

BRUSHES
No. 8 filbert

WATER-SOLUBLE OILS
Assorted

OTHER
4 pieces of colored paper • Piece of string • Scissors • Tape, stapler, or glue

QUICK TIP

MAKE A CROPPING TOOL
Cut two 90-degree angles (1 inch [25mm] wide) from an index card or piece of cardboard. Hold them together to form a frame. Use them to crop into a big painting or a still life setup. Use them when painting out of doors to frame your subject.

1 Create Your Subject
Cut up four colors of construction paper into ¹/₂-inch (12mm) strips. (If you want to do what I did, make connecting circles into one continuous chain.) Tape or staple pieces together to make a sculpture. Hang it with the string or arrange it on a piece of white paper.

2 Sketch and Paint Your Subject
Sketch it with a pencil on an 8" × 10" (20cm × 25cm) paper, then paint it using all of the colors that you want.

3 Crop an Area From the Painting
Use your cropping tool to select part of the painting. Create a big painting (16" × 20" [41cm × 51cm]) of that selection using a big brush. Have fun.

Three More Creative Activities

MATERIALS

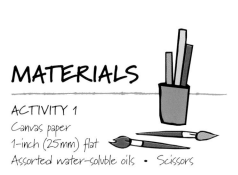

ACTIVITY 1
Canvas paper
1-inch (25mm) flat
Assorted water-soluble oils • Scissors

ACTIVITY 2
Canvas paper • Brush • Index cards •
Oil pastels • Sketch paper (large)

ACTIVITY 3
Construction paper • Glue • Still life

Activity 1: Weave Paintings Together

With a big brush, paint a piece of canvas paper with red. When that dries, do a quick painting with a big brush of a bouquet of flowers over the red color. Wait until the paint is dry, then cut it into ½-inch (12mm) strips and weave the pieces together. You can make your result much bigger by cutting up two more old paintings and alternating the strips. Or make many small weavings; trim the ends and make a patchwork art quilt. Remember to keep the weave tight by pushing all of the strips to the middle.

Activity 2: Using Music for Inspiration

Turn on your favorite lively music. Try to depict the rhythm of this music with a continuous pastel line that fills the width of your entire sketch paper. Use the edges. Express your feeling through this line. Keep it moving until you feel that it is done. Keep listening to the music and keep the feeling flowing. On a canvas paper, do a larger painting to that music. Be generous with the paint. While it is still wet, cut up some pieces of canvas paper or use index cards and press a piece on the wet painting. Lift up and let dry. Take another piece and press it against another part of the painting. You can make some lovely transfer prints this way. Ask your hardware store for a discount on some cans of unpopular colors of wall paint if you want to work really big.

Activity 3: Create a Paper Still Life

Set up a still life: a bowl of fruit on a table, a chair behind the table. Pick five colors of construction paper. Tear (rather than cut) each shape to represent paint in your still life and glue it to a colored sheet of paper. When you begin your painting, you will have a good sense of its design. It is a good vehicle for understanding the relationship of shapes. They can be easily rethought and moved. Try this with colored tissue paper for variety.

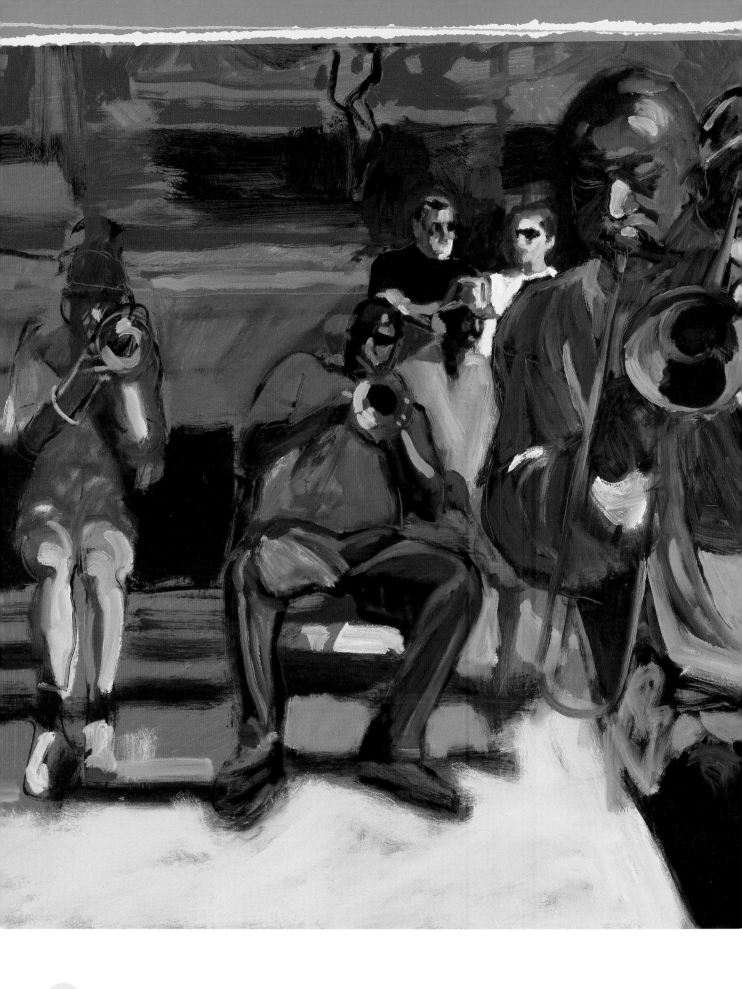

I always stress in my classes how important it is to recognize that each person is unique. We each have a different voice, a different handwriting, a different fingerprint. We all see the color of the evening sky in a different way and have hopes and dreams that no one else has.

Is it any wonder that our paintings all look different? Why would we want them to be anything else? They are an expression of who we are. Let them be just that.

I hope to allow you the freedom to paint the way you want, but still teach you how to get where you want to go by learning to mix great colors and use them in a way that makes them exciting.

I hope that you will learn to paint exactly what you want, but if you want to sell your paintings then you must appeal to the people who buy them. Few people care about seeing your nightmares, your dark side, or your anger. Most people want to be uplifted, shown beautiful colors and taken away from their dark side. However, this does not mean that all paintings have to be about flowers, puffy clouds and teddy bears. Beauty can come from the use of great color combinations, an orange sunset or the reflections on a river.

Why We Enjoy Art, Paintings and Color

I was curious as to what it is that makes us so attracted to color. I asked my husband, a psychiatrist, because I wanted a scientific answer. This was his reply.

"Scientists believe that all pleasurable experiences come from the release of small amounts of a brain chemical in a specific region of the brain. All pleasure seems to be based on this change, for example, food, sensuality, things we see and hear. While the exact mechanism is unknown, the chemical that we think is released is a neurotransmitter molecule *dopamine*. It is released in a group of nerve cells called the *nucleus acumbens* deep in the brain. We believe that without the release of this chemical at this site we would experience nothing as pleasurable."

—Daniel A. Deutschman, M.D.

N'ORLEANS TROMBONE PLAYER
24" X 30" (61cm X 76cm)

Glossary

Alla Prima Italian meaning "at the first." Doing the entire painting in one session (as opposed to doing it layer by layer).

Backlight Light source that comes from behind a subject.

Blooming A whitening of a varnished surface resulting from bad varnishing conditions or inferior varnishes.

Cadmium A pigment (Cadmium Red, Yellow, Orange) that is considered toxic if ingested or inhaled. Be very careful using paints containing this name.

Chroma Brightness of a color or object.

Color Temperature Warm (sunny colors like yellow and red) or Cool (icy colors like blues and greens).

Colorist One who has mastered color as a major means of expression.

Complementary Colors Opposite colors on the color wheel, for example: red>green; yellow>purple; orange>blue.

Composition Arrangement of elements in a pleasing way by an artist.

Diptych One painting done on two canvases or any piece of art done in two sections meant to be shown side by side

Easel A structure to hold an artist's canvas.

Fat-over-Lean Fat: Paint with oil added. Lean: No oil added or paint thinned with turpentine. The proper way for paint to be applied. Paint applied thin over thick (lean-over-fat) causes paint to crack after aging.

Fauvism (1905-1908) The Fauve painters were the first Avant-Garde movement of the 20th century. When this unknown (Matisse, Braque, Duffy, Derain, Vlaminck) group of painters was introduced in Paris, they became known as the Wild Beasts of Color because of their vivid use of pure colors.

Ferrule The metal part of a brush that holds the hairs in place.

Gesso Glue sizing reinforced by whiting used as a primer.

Glaze A thin film of transparent color laid over a dried underpainting.

Ground Color This helps establish tonality that brings harmony to the entire painting. It furnishes a structural layer between support and painting.

High-Key Values in the upper or lighter range.

Hue Actual color.

Low-Key Values in the lower or darker range.

Masonite A painting surface that has one rough side and one smooth. It is prone to warping. Priming all sides reduces risk.

Muddy Color Colors described as muddy result from mixing together too many colors. You know they are muddy when they turn that yucky-purply-lifeless color.

Naptha Soap Fels-Naptha soap is a heavy-duty laundry bar soap that I use for brush cleaning, not to be confused with *naphtha*, a term applied to several volatile solvents, which can be an eye and skin irritant.

Negative Space Consequent space resulting from a positive shape.

Oil Pastel A dustless crayon made with pure pigment and an oil soluble wax binder. Add Liquin or thinner and it can be easily moved around with a brush or cotton swab.

Opaque Opposite of transparent—other colors or the surface won't show through an opaque color.

Palette Surface for mixing paint. An artist's choice of colors.

Palette Knife A spatula-like piece of steel with a rounded end and wooden handle used to move and mix paint.

Pigment A powdered coloring material used in making paint.

Plein Air French "open air." Painting outside directly from a subject.

Primed Canvas Has one or more coats of gesso applied to the raw canvas to keep the paint on the surface (rather then soaking into it).

Props Something giving support to a composition, for example, objects in a still life other than its subject or flowers in the background of a portrait.

Sizing A liquid used to fill pores and make surfaces ready to receive coating.

Stretchers Wooden bars over which the canvas is stretched and tacked or stapled.

Solvent A substance, usually liquid, used to dissolve, thin or remove another substance such as paint.

Support Surface used for painting (paper, canvas, masonite).

Texture Giving the illusion of surface.

Thinner A fluid (turpentine or mineral spirits for traditional oils, water for water-soluble oils) used to decrease the viscosity of another.

Tone Value: light or dark.

Transparent Colors that transmit light and have a clear quality.

Underpainting A thin, flat layer of paint applied to the canvas before the painting begins. This color traditionally was a neutral, but it can be any color. The underpainting unifies a painting when some of its color shows through after a painting is done.

Value Tone; lightness or darkness of a color.

Varnish A protective film brushed or sprayed on a water-soluble oil painting that has dried for six months to a year.

Viewfinder Framing device to help you focus on a subject.

Winch A pulley system with a crank for hoisting or lowering large paintings.

Index

QUICK TIP

READ ANOTHER RESOURCE
Sean Dye has written a book called PAINTING WITH WATER-SOLUBLE OILS, (North Light Books) containing useful information on the technicalities of water-soluble oils.

The best in fine art instruction and inspiration is from North Light Books!

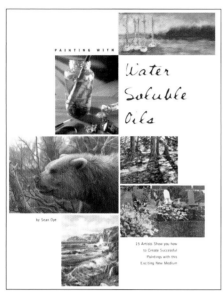

This invaluable guide provides painters of all skill levels with the information they need to successfully work in this exciting new medium. They'll learn what water-soluble oil color is, its unique characteristics, and why it has generated so much enthusiasm among artists. Readers are then presented with the basic approach for working in water-soluble oils.

ISBN 1-58180-033-9, hardcover, 144 pages #31676

Knowing how to use a brush properly is essential for effective oil painting. Brushwork Essentials shows you everything you need to know to render a variety of elegant strokes, along with other exciting techniques like paint mixing and brush shaping. Follow detailed step-by step instructions and complementary artwork that highlights each brushstroke as it appears on the canvas. You will also learn how to use different strokes to achieve specific effects, such as lighting, shadowing and more.

ISBN 1-58180-168-8, hardcover, 144 pages, #31918

Capture the stunning beauty of the seasons, in oils, with an accomplished artist at your side. Follow step-by-step lessons that teach you how to understand light and truly see your subjects. Work through exercises to master shape, value, color and edges - the four keys to successful painting. Compare the same scene painted in all four seasons, side by side. Gain useful bites of information through tip boxes in every section.

ISBN 1-58180-476-8, hardcover, 128 pages, #32744

Achieve beautiful paintings today! Beloved TV painter Brenda Harris brings you a book with 13 acrylic projects that anyone can paint. Heartwarming scenes included range from landscapes and barns to birds and interiors. It's fast and fun to paint beautiful acrylic scenes with Brenda Harris.
ISBN 1-58180-659-0, paperback, 112 pages, #33254

These books and other fine art titles from North Light Books are available at your local arts & craft retailer, bookstore, online supplier or by calling 1-800-448-0915.